Shoes. Objects of Art and Seduction

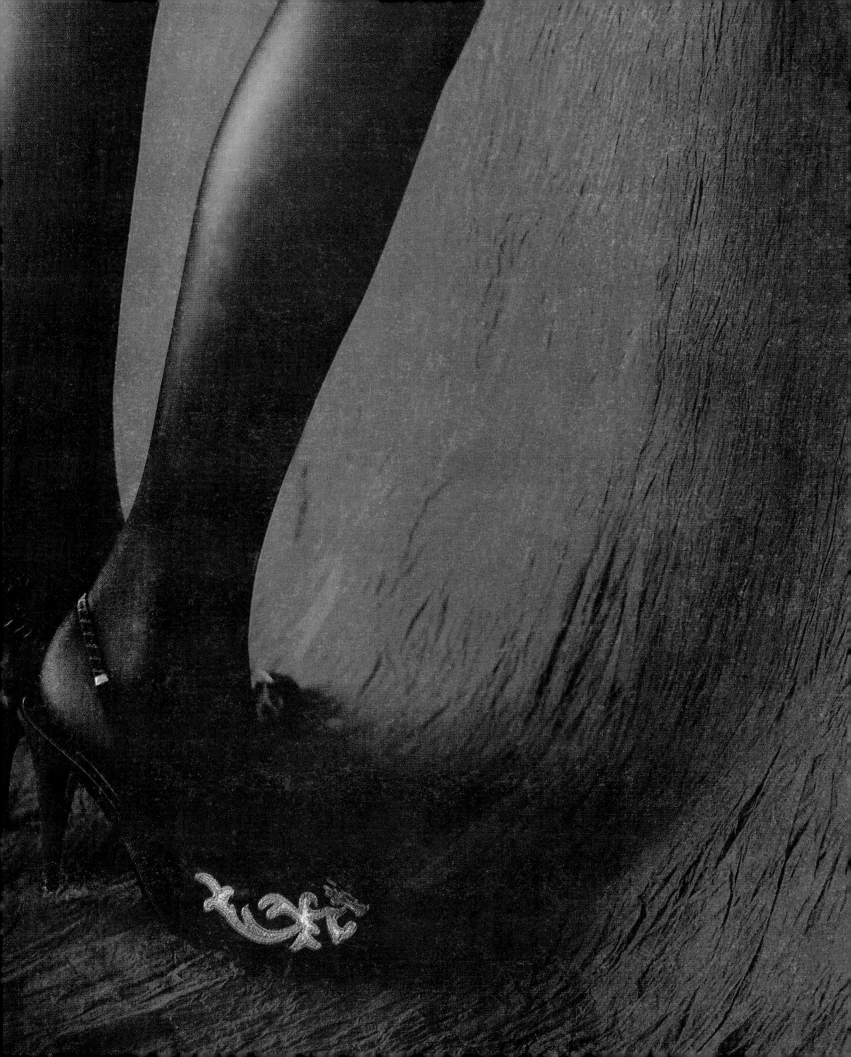

Paola Buratto Caovilla

SHOES
Objects of Art and Seduction

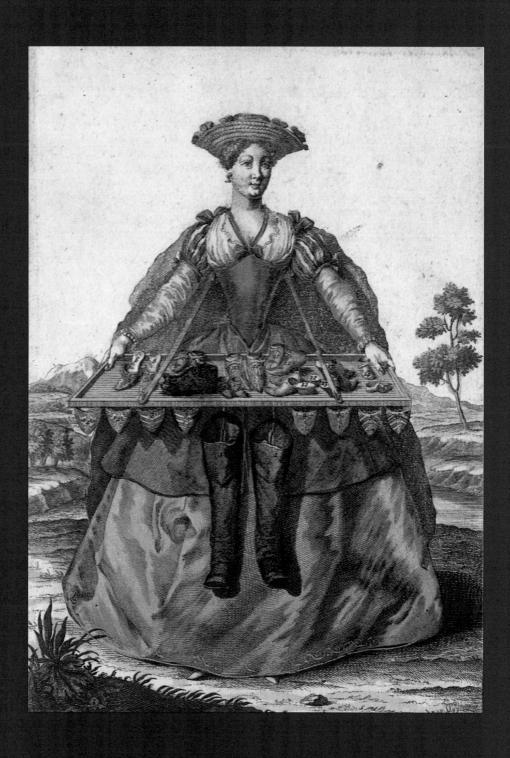

Une Cordonnière, circa 1750, coloured engraving

published by M. Engelbrecht, Augsburg

Not all shoes are made for walking, but all can seduce.

The blown glass of a museum, the small lace shoe in an eighteenth-century painting, the enchanted garden of Giverny: the path is always the same. Different stages, linked by the love of elegance, but above all by femininity, which, in any case, is seduction, on a path giving rise to the idea, the Idea of Light.

The meticulous search for details accompanies the gestation of footwear until the final synthesis that makes it an Object of art and, once again, of Seduction.

Cover
Snake, René Caovilla, 1990
(Cover photo by Amendolagine e Barracchia)

Graphic Design
Marcello Francone

Editing
Anna Albano

Translation
Leslie A. Ray

First published in Italy in 1998 by
Skira Editore S.p.A.
Palazzo Casati Stampa, via Torino 61,
20123 Milano, Italy

Printed and bound in Italy. First edition

ISBN 88-8118-470-2

Distributed in North America and Latin America
by Abbeville Publishing Group,
22 Cortlandt Street, New York, NY 10007, USA.
Distributed elsewhere in the world
by Thames and Hudson Ltd.,
181a High Holborn, London WC1V 7QX,
United Kingdom.

Particular thanks to
Anna Albano
Arena di Verona, the Theatre
Fulvia Bacchi, UNIC
Bally Schuhmuseum, Schönenwerd
Manolo Blahnik
Attilio Codognato
Alberto Dal Biondi
Christian Dior
Fondazione Ligabue, Venice
Brunella Frusciante
John Galliano
Rosalba Giorelli
Ralph Lauren
Katell Le Bourhis
Giancarlo Ligabue
Fredy Marcarini
Musée des Beaux-Arts, Caen
Museo di Ca' Rezzonico, Venice
Carlo Nordio
Palazzo Grassi, Venice
Pancaldi
Giulia Pirovano, ANCI
Andrea Guolo
Luigino Rossi
Maurizio Scaparro
Paolo Singaglia
Teatro Eliseo, Rome
Clauco B. Tiozzo
Valentino
Gianni Versace

CONTENTS

I trust the reader will forgive these lines written by a professional in law who has the temerity to talk about fashion. But the human spirit has this unusual aspect, that it aspires towards the unity of concepts if not of intentions, and tends to associate those aspects of life that make it enjoyable: the beautiful, the good and the just. Justice also has its harmony, just as forms, in their proportions, have their equity. Our taste is irritated by all that is exaggerated, just as our senses are hindered by what is excessive: too much light blinds, noise deafens, and dishes that are too seasoned lose their flavour. Observing a painting from too close or too far away means not seeing it. Even what is too obvious is difficult to comprehend. Aesthetics and justice agree inasmuch as both are the offspring of balance.

But justice and fashion have another thing in common: both are severe in their dictates. One can deprive us of our liberty, the other of social consent, and both marginalize those who do not obey their precepts. Malicious gossip about coarse footwear can be more cutting than the reprimand of a frowning judge. That is why fashion reaches where no other authority would succeed in imposing itself. To meet its rigid canons, women—but often also men—have always humiliated their bodies in uncomfortable clothing and mortified their appetites with stylists' fasts. There are people who bear an unjust sentence, but suffer over a missing compliment.

This book discusses an object of art and seduction. Of art, because it is the fruit of centuries of refinements, of experiments, of creativity. But also of seduction, because, in contrast with other inanimate objects— porcelains, furniture, crystal glass—shoes take on an extraordinary vitality thanks to those who display them. Like clothes and jewels, shoes give and receive a magic splendour because they are both the cause and the effect of a message of desire.

Yet beauty is not necessarily linked to sexual desire. As with all absolute categories, it is a container that each can fill with their own aspirations:

it can include the force of wealth and power, but also that—perhaps greater and certainly nobler—of devotion and charity. The warrior's boot can evoke the galloping heroism of the fields of Austerlitz, just as the Pope's slipper, kissed by monarchs, expresses the supremacy of spiritual power. But the sandal of the Franciscan and the mules of the Red Cross nurse can fill us even more with emotion, because they translate the best part of us into images: at least as we would like to be, if we cannot actually succeed in becoming it. The beauty of altruism is greater than that of a symphony: 'I do not know any other sign of superiority', said Beethoven, 'than being good'. Nevertheless, fortunately, the majority of us waver between the extremes of vice and perfection: we are never either completely good or bad, stupid or intelligent, elegant or shabby. But this does not count. What counts is the fact that we know we are. Just as wise ignorance consists in recognizing the limits of our knowledge, thus our intelligence consists in aspiration, and not in possessing. If we were perfectly right, wise and beautiful, we would be gods, and our life would be just as boring as that of the idle inhabitants of Homer's Olympus. Yet we are imperfect, and it is in this that the small amount of happiness we enjoy in this life lies. You will be wondering what this has to do with the book you are about to read. It has a great deal to do with it, because all the footwear items you will see published are creatures of the desires, imagination and aspirations: both of those who have constructed them, by the candlelight of Medieval winters, or amid the comforts of modern workshops, and of those who observe them, appraise them, acquire them and wear them. Dreaming of a pair of shoes can be as beautiful as having them. As in all things, the pleasure of a purchase consists in its anticipation.

One final thing. Nobody is capable of defining what is beautiful and what is not. All those who have tried have spectacularly failed. Human reason does not possess objective instruments for defining these absolute categories. But logic is not our only instrument of knowledge.

If the heart has reasons that reason does not know, intuition has refinements that surpass the limits of our intellect. We *feel* that a thing is beautiful, even if we cannot explain why. And thus, seeing these images, we will have the mysterious perception of small masterpieces. This too, though it may seem strange, will make us a little better. Because I believe that the emotion of the beautiful is profoundly educational. With the appropriate exceptions, History teaches us that people of good taste are rarely soiled by degrading misdeeds. Because beauty favours that benevolence towards things that becomes indulgence towards our neighbours, and also towards ourselves. Before a work of art, albeit of minor art, it is nicer to forgive offences, or in any case, it is easier to forget them.

Egyptian silver sandals
belonging to a princess
of the New Kingdom,
Early Egypt, 1400 B.C.
Centro Studi e Ricerche Ligabue,
Venice

12

The goddess Seduction
made a wager with herself
that she could
enchant Time.

Perfumed and wrapped in enchanted veils,

she combed her hair and contemplated her image in the mirror.

Yet something was missing.

She smiled.

She put silver on her feet

and went to meet Love.

BEYOND FUNCTION

To consider shoes as solely a means for walking would be very reductive. From ancient times to today, in fact, they have been the bearers of meanings well beyond their function: a symbol of power, an instrument of seduction, distinguishing class, the cause and means of repression.

Men used them initially to affirm their own strength: domination over nature, objects to protect the feet for more comfortable and fruitful hunting, the privilege of most powerful. From a means of ensuring the superiority of man over the world, shoes were quickly transformed into symbols of the domination of man by man. The Hittites considered footwear as a divine attribute, the gift of the Storm God; for the Egyptians they were to become the indicator of social position. And so it was until the time of the Ancient Greeks; the Romans denied them to slaves, so they could not have the means with which to run away; they were used in Medieval times by knights and in the Late Middle Ages by merchants. In the England of the fourteenth century, those who did not have at least forty pence per year in income could not show off the tips of their shoes.

TOWARDS THE FEMALE DECLINATION

In the phase of transition from use for the purposes of pure utility to the object bearing symbols, shoes found the female foot to be the natural seat in which to manifest recently acquired attributes. The evolution of style within the sphere of the production of women's shoes does not find any justification of a practical order: the form, the decoration, the exhibition or failure to exhibit reflects the culture of the various ages. Where a climate of liberality exists in the relationships between the sexes, women are granted a wide margin of freedom; in the cultures in which femininity is repressed, imprisoned, the naked foot

represents an enemy to be combated on sight.

Since the dawn of time, shoes were designed and made with luxury materials. The richer social strata among the Assyrians, for instance—including the army—could not do without shoes embroidered in various colours. Among the Persians, a soft and high shoe appeared, the Persian, adorned with ornamental elements, a luxury shoe for the rich woman, belonging to the high society.

EGYPT

In Ancient Egypt the shoe was the prerogative of the class in power. Climatic necessities imposed a thick sole, which offered protection from sandy and hot ground; but the upper allowed the foot to breathe, allowing full freedom of movement: it was the birth of the sandal. Egyptian aristocrats had their feet almost completely uncovered, wore clothes made of light, probably transparent fabrics. For women the moment of body care was fundamental: they had recourse to oils, perfumes and to all the substances available for this pagan kind of rite. Judging by the iconographic evidence that has reached us from the past,

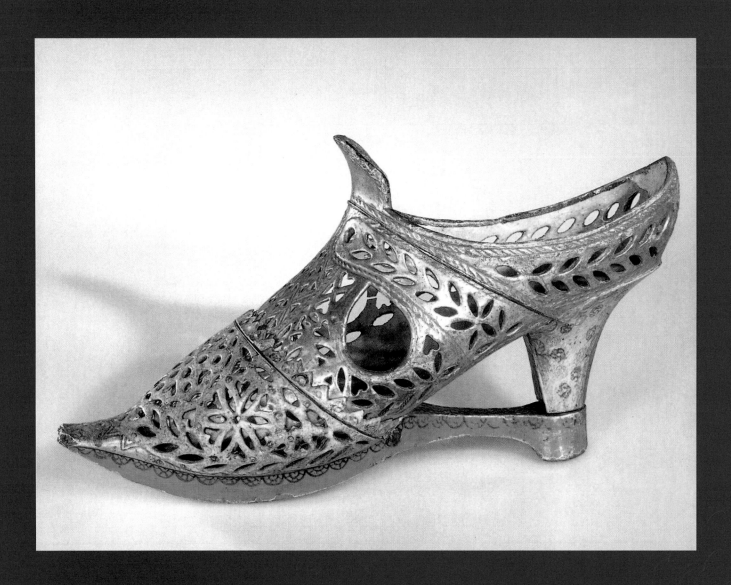

Wooden footwear with undershoe,
1650, inlaid and gilded walnut.

the Egyptian era had an unusually sensual aspect. The fascinating legend of Queen Cleopatra, capable of arousing attraction even when old, must have built up her bases on a real peculiarity of the Egyptian woman: from the prey of foreign power to the enchantress of Roman generals.

GREECE

The Ancient Greeks, substantially the inventors of the whole range of prototypes of footwear for subsequent centuries, were more practical than their predecessors. The form of the shoe took the shape of the foot, as would be natural. For a long time, however, this simple logical consideration had been combated, giving rise to footwear as a full-blown status symbol. The 'technical' shoe appeared, footwear for particular occasions. In a society that discovered dramatic art, the theatre had its own special models, the cothurni, surrounding the creation of which various legends are told. The attention reserved for the foot, the organ of the body responsible for movement, prompted the Greeks to diversify their creations. In the end the shoe was to distinguish the free man from the slave: free men, aware of the importance of this distinction, were to bend over backwards to make sure slaves could not have recourse to them.

The different colours of footwear identified the various social categories. Courtesans used shoes for their work of enticement, preferring the crepida, a type of shoe that made a particular noise when walking, sufficient to attract the attention. The high sole was the symbol of aristocracy, distinguishing the rich from the poor, who used wooden sandals (when they could).

With the passing of the centuries the first calls were to come to return to the origins, the shouts against the decadence of customs: shoes were to be the privileged object of this. In the meantime, however, little remained of the original idea: shoes continued to be proposed as status symbols.

A
 new world,
a world of seductive
and curious novelties.

Seduction of the future,

that the tips of shoes

face with safety.

Seduction of the past,

of the side that the mirror does not show us,

of the roads that have loved

the music of our heels.

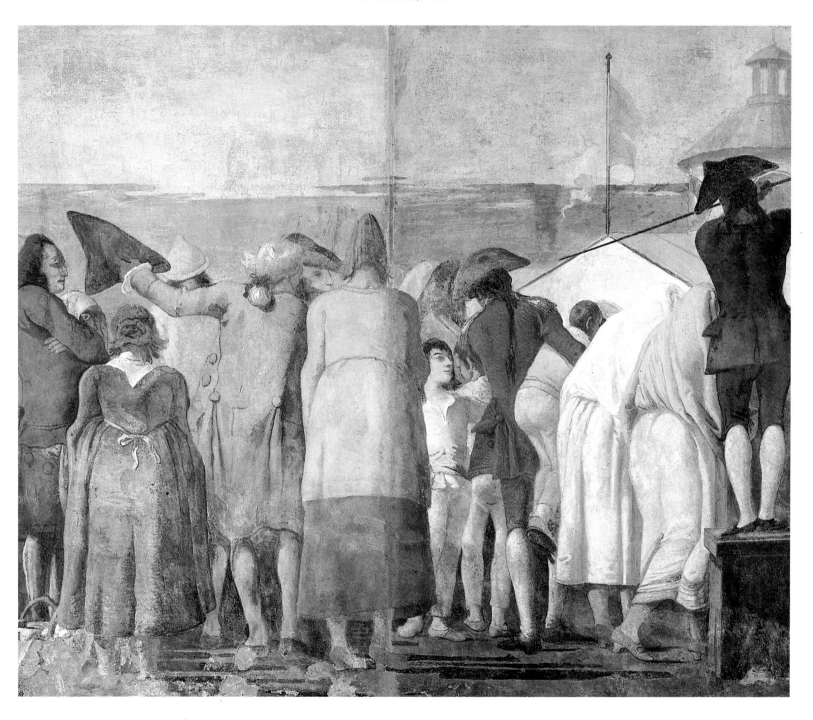

A crowd of citizens and holiday makers crowd around the hut where images of far-away worlds are projected (Mondo Novo), commented on by a man standing on a stool. The figures have their backs to us, and are immobile: everything speaks of the consternation before the awareness of a century about to depart and the heralding of a world as yet unknown.

ROME

The shoes of Roman emperors and senators were red. Military victory was revealed in the wealth of the materials: gold and silver in the sole, golden and bronze nails in the *caligae*. The colour, which in Rome was a symbol of power, brought out the charm of the footwear of Roman women, who were also given freedom of choice of materials: a freedom, however, that was not exempted from some impositions. The *domina* enjoyed the privilege of covering the foot, thus being able to wear closed shoes. The shoe started to become a fetish, the object of desire that the prostitute, for instance, could not afford. Paid-for love could hide nothing: the metaphor for this was the use of the sandal. Slaves remained barefoot, so that they could not run away: free men wore shoes whose materials and workmanship varied according to their economic possibilities.

Before the fall of the Empire, the woman could play the role of the seducer, allowing the form of her foot to be imagined, before uncovering it freely. In the years that followed, femininity was to be transformed from a call to the game of love into a peril and a source of sin; abstinence was to become a virtue. Covering was to become an obligation and no longer a choice: simple functionality was to prevail over the pleasure of ornamentation.

BYZANTIUM

A splendid exception was to be Byzantium, the heir of the ancient empire for another millennium. The colour remained, acquiring new meanings: it remained a symbol, such as green for the aristocracy, but also the exhibition of wealth. Beauty was an absolute paradigm and went hand in hand with luxury: the foot was covered with treasures. The woman of Byzantium appeared as a message to

posterity, the shining icon of a femininity that was not humiliated. The shoemaker's art evolved in the tanning, in the workmanship of leather. The forms changed slowly: the light sandal still prevailed, yet was produced with more precious hides, the choice of which was enriched by contacts with the populations of the Middle East. Under the long and flowing dresses, the foot was hardly visible. The movement accompanied the ideal lightness of women: carnal in their footsteps, spiritual in their stasis.

THE FALL OF THE EMPIRE AND THE ADVENT OF CHRISTIANITY

In the West the collapse of the Empire brought about the loss of order and social security. The triumph of Christianity and the lowering of living standards were to change the conception of luxury, which became substantially a hereditary commodity.

In this period footwear was an object of enormous value: a pair of shoes could not fail to be present, for instance, among the gifts sent to the Pope by kings. Objects in use exclusively among powerful people, shoes no longer needed to speak of their owners: the sign of distinction became possessing a pair.

The father of the bride transmitted authority to the future son-in-law by giving him a shoe belonging to the daughter, which therefore became part of the female dowry. The predominance of man over woman, more accentuated compared with the imperial era, was symbolized by beating the shoe on the head of the bride. Centuries before free men enacted their predominance over another man with a similar gesture—a foot on the neck.

The advent of Christianity, with all the implications that the concept of sin brings with it, decidedly humiliated the public expression of femininity. Subject to the authority of the husband, forced to renounce se-

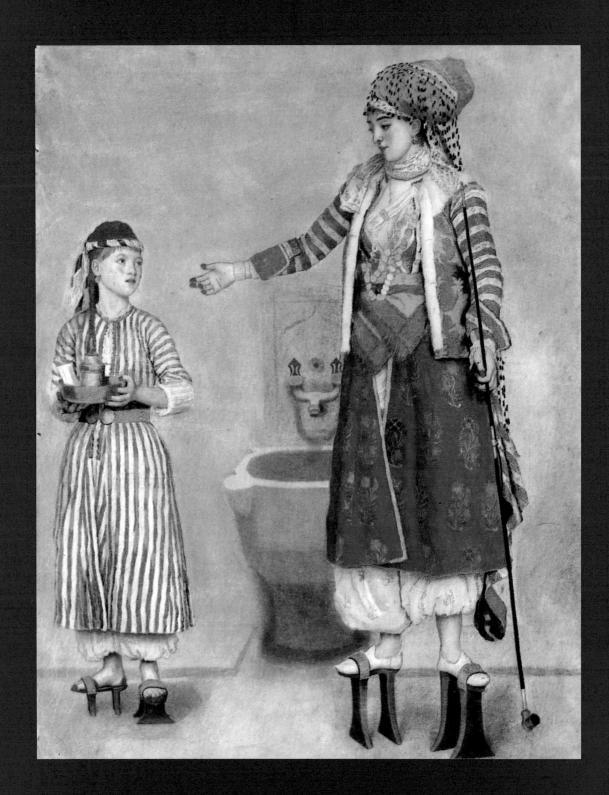

Chopines

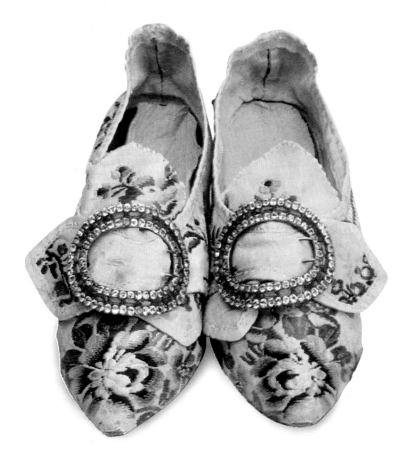

duction and body care to remove temptation, women were forced to cover their feet. Only the vows of chastity and poverty offered dignity to the naked foot, part of the impure body: the Franciscans were to make it the symbol of humility.

The woman, therefore, the source and transmission of original sin, was left with no other choice than to also cover the extremities. The covered foot spoke of female modesty and reserve: the shoe, the element of decoration independent of the rest of the clothing, was to become part of a single long dress going down to the feet. In an age of triumphant spiritualism, the seductive function of the foot, the symbol of the animal part of the human being, inevitably exhausted itself.

WALKING TOWARDS THE SIXTEENTH CENTURY

At the turn of the millennium, however, the appearance of a middle class offered new nourishment for fashion trends. The shoe maintained its value as display, but returned to being a

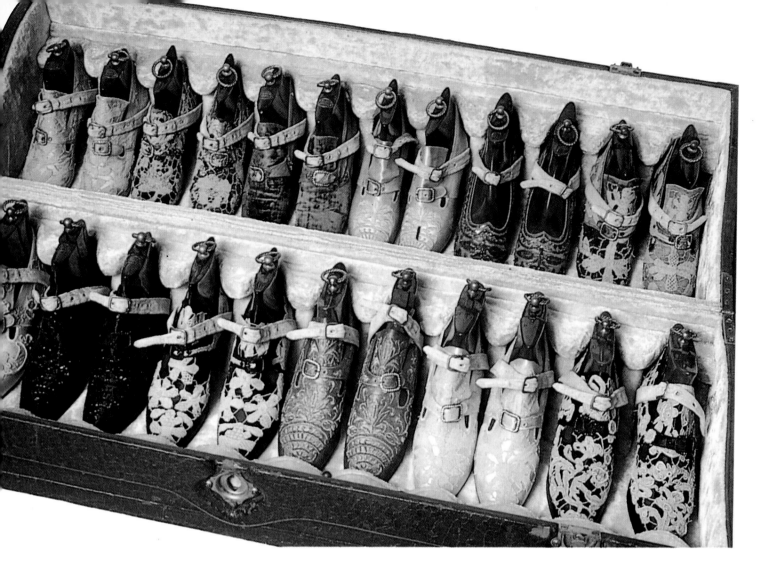

mass commodity, albeit that of a rich circumscribed mass: it was no longer the exclusive prerogative of nobles and clergy, but a widely diffused object in a class that cultivated a new competitiveness within itself, stimulated to a large extent by the new commercial contacts with the East. The shoe once again freed itself from the concept of a strictly functional use: the decorative element and the consequent use as an attraction returned.

With time the patten, created to isolate the foot from the impurities of the street, grew ever taller: a female challenge to the tape-measure, which anticipated what was to happen subsequently with heels.

Footwear returned to having an erotic appeal: the debate on the phallic form of the *poulaine*, the pointed shoe from the Late Middle Ages, lasted for a long time, and the tape-measure challenge, with ever longer tips,

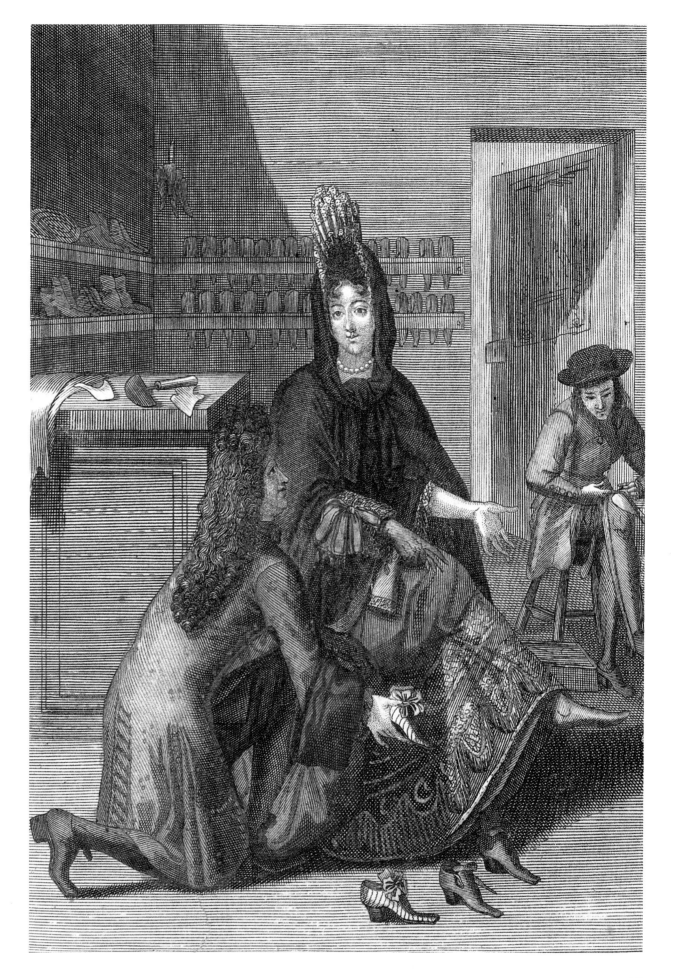

*Anonymous Frenchman,
late seventeenth century,
coloured engraving*

which took place between the nobles of the age must have been significant. Only an innocent parlour game? The model of *poulaine* with a chain seems to deny this thesis. The allusion seems clear: the foot is the most exposed part of the body, the appropriate part to launch an unequivocal message. And the battle of the dimensions must certainly have provoked some embarrassment among the noblewomen of the fifteenth century. Let us not forget, for the first time women wore clothes that were not closed: indeed, the button appeared, and with it the idea of a body exploding and barely contained. Sensuality and seduction thus reappeared, and the reaction, as often happens, fell on deaf ears: in France and England the tips of the *poulaine* were forbidden to the poor man and controlled by regulations for the rich: the maximum length was in fact only permitted for the nobles. The Church, for its part, condemned it without right of appeal. Where morals did not succeed, however, the malformation of the king won through. Charles VIII, who according to legend had a foot with six toes, was forced to use wide, square shoes, the so-called duck's bill shoes, thus contributing to the definitive decline of the *poulaine*.

It is said that Venetian men made their wives wear heavy wooden chopines to prevent them from getting lost.

THE SIXTEENTH AND SEVENTEENTH CENTURIES

Between the sixteenth and the seventeenth centuries, footwear encountered a phase of further evolution. The use of the boot spread, often long up to the thigh and adhering to the skin. Women wore shoes with square tips and without the rear part, and these took the name of slippers. In Venice, the bridge head with the East, the Turkish influence of the *chopines* arrives: these were small 'stilts' created to gain access to the baths, insulating the feet, but they immediately be-

came the pretext for challenges between ladies, once more in terms of measurements. The predictable restrictions imposed on the use of this seductive footwear went unheeded, and *chopines* reached such dimensions as to make it necessary to use a walking stick. A conspicuous return of femininity was already sounding its trumpets.

The need to isolate the foot for hygienic reasons became a pretext for sensuality.

With this spirit, in the seventeenth century, the heel for women's shoes imposed itself. The shoe followed the fashion trends of the century, which envisaged clothing abounding in curves to accompany and enhance the female figure. Heels changed the movement and the very shape of the body, accentuating the breasts and the curvature of the buttocks. After over a century of femininity denied, the shoe showed off the woman's body to the greatest possible extent. The heel took on different forms and lengths, dictated sometimes by the whim of a powerful man: it even seems that the Sun King imposed low heels in his

*V*enetian chopine,
seventeenth century

*L*arkin, Richard Sackville,
Third Count of Dorset,
1613

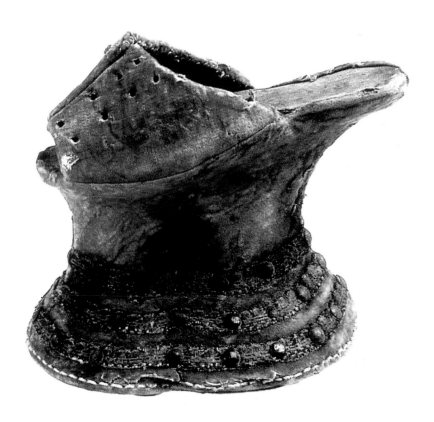

V*enetian satin slippers,*
with fringed embroidery.
Venice, private collection

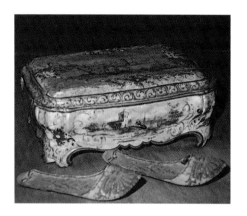

W*oman's shoe, late*
seventeenth century,
Venice, Museo Correr

F*inely embroidered satin*
shoe, with applications
of semi-precious stones,
early 1900s. Venice, private
collection

S*atin shoe with multicoloured*
thread embroidery
and reel-shaped heel,
France, 1785.

There are very few countries where the belief does not exist whereby shoes bring good luck to lovers and newlyweds. They represent fertility, stability, prosperity and harmony.

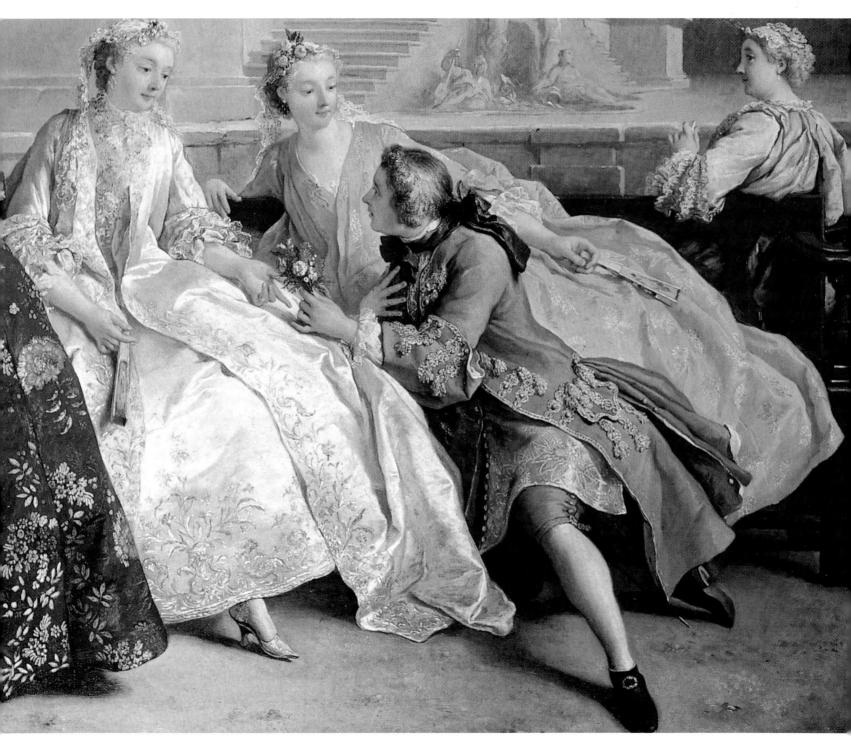

Jean François de Troy, The Declaration, *Berlin, Potsdam, Sans Souci.*

Marie Antoinette was endowed with that subtle quality of being, something rather disturbing for a queen, and difficult for history to transmit: seduction. All her life, in her own way and with quite different interlocutors, she was an 'enchantress queen'.

The last moments of Marie Antoinette

After the trial, Marie Antoinette is taken to the 'bathroom of the condemned' for the brief interval before her execution. [...] She prepares herself with care, in the spirit and in the body. She has given up her mourning dress, as requested, it being judged too shocking, and has dressed in white. She wears black stockings and fine heeled shoes, the only reminder of past luxury.

Taken from Chantal Thomas, *Marie Antoinette ou les malheurs de la séduction*

'... Elle fascine par sa jeunesse,

sa finesse, sa blondeur,

sa démarche ...

Parce qu'elle marche

comme à l'écoute

d'une musique

par elle seule entendue ...'

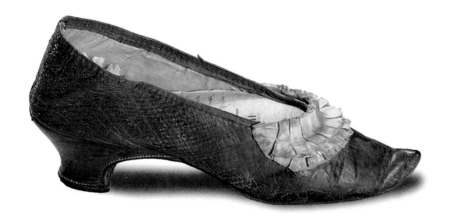

The shoe worn by the queen
of France, Marie Antoinette,
at the moment she went
to the scaffold.
Caen, Musée des Beaux-Arts

Le soulier transcende

ce qu'il touche.

Le sol est une dune blonde,

gracieuse, pailletée,

renvoyée sur elle-même

par le jeu des miroirs

qui multiplient son éclat ...

Taken from Chantal Thomas, *La Reine scélérate*

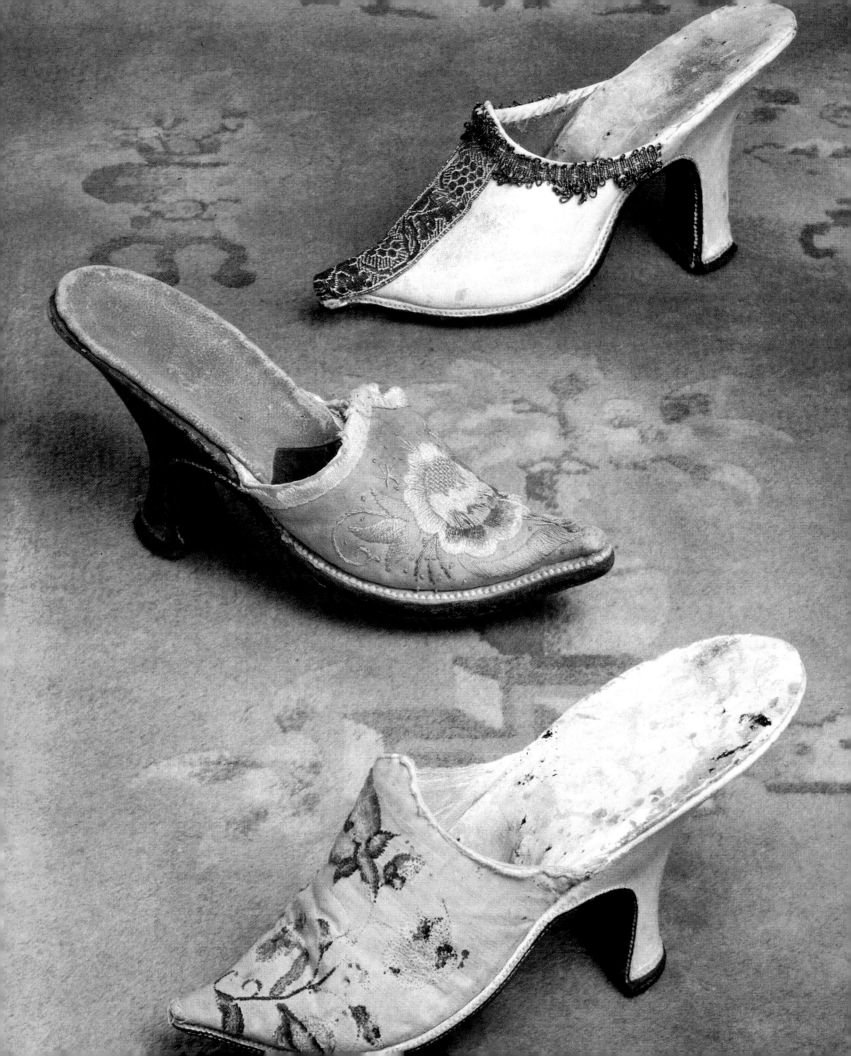

court so as not to be exceeded in stature. The red heel became the royal heel, complimentary to the imperial annals of Ancient Rome.

FROM THE FRENCH NINETEENTH CENTURY, AWAITING THE REPUBLIC, TO QUEEN VICTORIA

In Bourbon France the shoe took on significance as the symbol of social disintegration, transforming itself into a visual element of revolt against the nobility. The revolution decreed the disappearance of heels, at least until the Restoration, but the form of erotic communication set in motion through the prominence given to female forms continued its unstoppable progress.

The victory of the bourgeoisie paved the way for the affirmation of haute couture. The nineteenth century, once the revolutionary parenthesis had been closed, again proposed the luxury of the previous century, but in more severe terms: from the Romantic phase to the new Rococo, to the Victorian rigidity of the turn of the century. Exhibition tended to be contained, competition to become more sober. The art of shoemaking picked up the inheritance of the historical age: though in an ample range of colourings, the heel, for example, became contained. Laces appeared for the first time in this context, the forced enclosing of nature inside the material.

The bourgeois philosophy was thus translated into the suffering and oppression of the concept of walking. The shoelace is an element of constraint, which radically transforms the act of wearing shoes. The nudity of the foot was not only hidden: seals were even affixed to it, in total conso-

nance with the prudish atmosphere of the end of the century, so that even at table, in the England of Queen Victoria, long tablecloths down to the ground were obligatory. Restriction nevertheless contained in itself the germ of its opposite: what promise do tightly sealed shoelaces hold within themselves, in fact, if not that of being untied?

THE TWENTIETH CENTURY

We thus arrive at the first half of the twentieth century, at the industrial production of footwear and the appearance of the first major stylists. The great war shattered the happy-go-lucky climate of the belle époque, but also paved the way for the first legends of the century, from André Perugia to Salvatore Ferragamo. The hems of skirts were suddenly shortened, fully revealing the ankle. There was rapid change, in Italy hindered by political and military circumstances. Fashion found itself at an *impasse*, the victim of the autarchic ideology. Models appeared of the 'Riviera' style, with bullet-shaped bottoms recalling a sad past and preannouncing an even less happy future. Across the border, the impassioned search for a new style continued, among the follies of Elsa Schiapparelli and the elegance of Coco Chanel.

The age contemporary to us, then, is another story.

English shoes, 1730

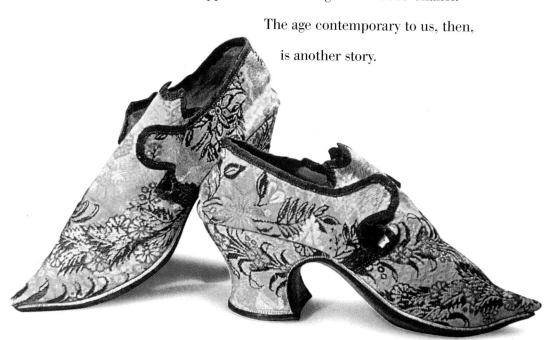

Model

from Fantasie d'Italia

Il merletto della nipote

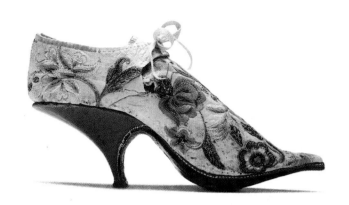

The craftsmen who worked in the

shade, following the evolution of

footwear step by step over the course

of the centuries, have left us memo-

rable creations, worthy of appearing

in the halls of museums throughout

the world: apparently improb-

able forms, subtle equi-

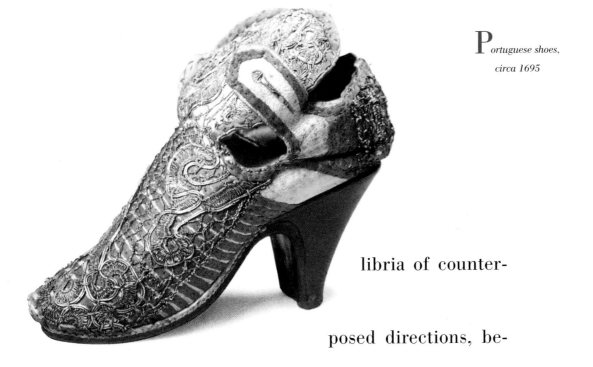

libria of counter-

posed directions, be-

tween the sky of the heels and the

ground of the tips. The hands of the

shoemakers, writing on precious ma-

terials, have cov-

ered our feet

with art.

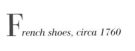

French shoes, circa 1760

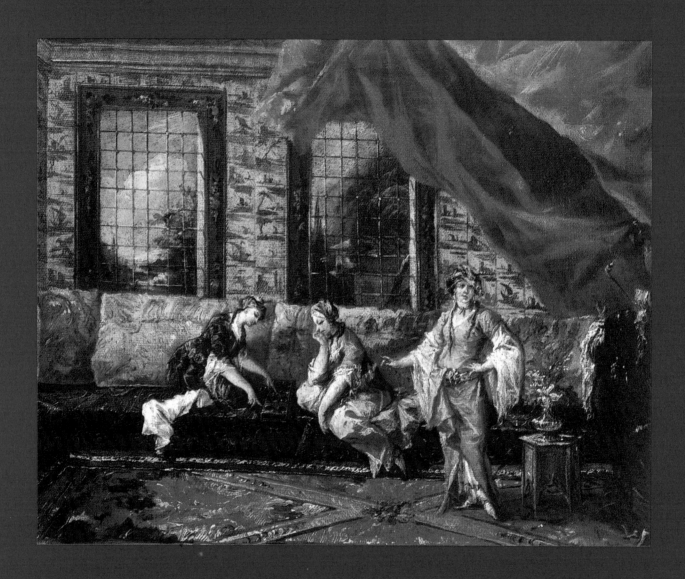

Francesco Guardi,
Odalisks playing mangala in the harem
1742-1743.
Düsseldorf, Kunstmuseum

*I*nebriating the senses and the imagination:

aroma of spices and far-off lands,

colours and sensations filling the eyes

and the touch with promises.

*D*amasks, embroidery, polished stones, pearls,

music absorbed by the smoke of the hookah:

the atmospheres of the famous 'turcherie' of Guardi.

*U*nconfessed fantasy:

abandoning yourself

to the sweetest slavery of love.

*T*urkish slipper, circa 1900

THE REREADING OF TWO MASTERPIECES

A second theme,

a more intimate

and perhaps no less true message,

full of imagination and fantastically surprising,

The work of art generally bears a title

as appears in the case of two well-known masterpieces:

that sums up its theme and message:

The Dance Lesson by Pietro Longhi

but sometimes can conceal another title ...

in the Gallerie dell'Accademia in Venice

and *Diana Bathing* by François Boucher in the Louvre,

whose titles we may attempt to change

—with full respect for their artists—

into *The Symphony of Footwear*

and *The Innermost Desire of Diana*.

In the *Dance Lesson*, the artist has created an unmatchable hymn to feminine innocence and grace in the blooming of youthful beauty. The centre of the composition, though with a certain malice, is situated in the ample skirt, moved down and to the right with respect to the median lines of the painting. Issuing from the white figure of the protagonist are bands of light irradiating admiration for her beauty and elegance. Amid so much chaste innocence, only her foot, finely shod, protrudes in a dance step. The other figures, from the dance teacher to the musician to the lady companion, revolve around her, as though in a vortex, in a spiral. Coquettishly the young woman shows only the beautiful oval of her blossoming face, the soft yet firm breast of Venus and the Cinderella's foot, showing only a glimpse of the ankle, an innocent yet coquettish stimulus for so many unexpressed dreams.

If we peer more closely to observe the scene more attentively, it seems that beyond the figures delineated there are others, luminously ethereal; it seems that a violin and the elegance of a shoe emerge beside the young woman, as phantasms of harmony and beauty evoked by the imagination of the protagonist.

Clauco B. Tiozzo

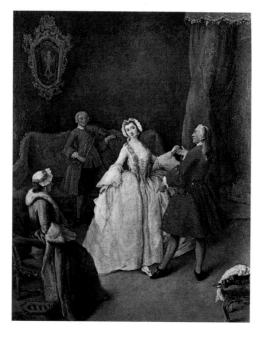

Pietro Longhi,
The Dance Lesson, *1741.*
Venice, Gallerie dell'Accademia

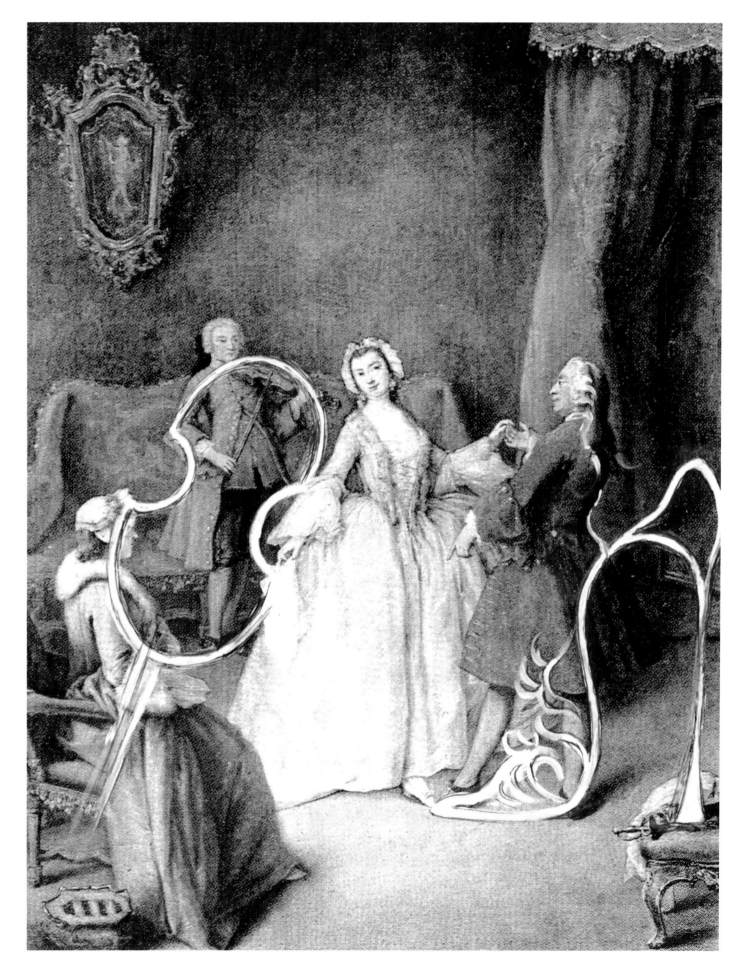

Pietro Longhi, *The Dance Lesson, or The Symphony of Footwear*, from C.B. Tiozzo, *Ritmi compositivi dell'arte della figurazione*, Venice 1970

In the painting *Diana Bathing* by François Boucher, the gentle-mannered Rococo painter of eighteenth-century France, the centre of the composition is asymmetrical and is Diana's instep. From the right hand of the handmaid on the ground, crossing the raised leg of Diana to the knee and continuing beyond her left shoulder, there passes one of the axes of the painting, while the other, which obliquely intersects it, passes through the head and bust of the handmaid, slipping onto the thigh of the goddess to touch the pearl necklace and her left hand, onto the white cloth. While the lines of the figuration intersect parallel to the main axes, the figures seem to rotate around the centre of the composition, giving the feeling of the harmonious movement of supple and splendid female limbs.

Clauco B. Tiozzo

*F*rançois Boucher,
Diana Bathing, *1742*
Paris, Musée du Louvre

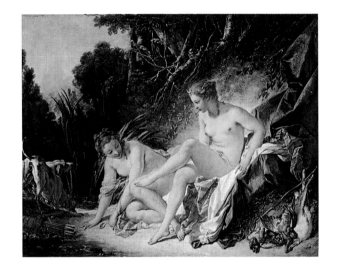

François Boucher, *Diana Bathing*, or *The Innermost Desire of Diana*, from C.B. Tiozzo, *Ritmi compositivi dell'arte della figurazione*, Venice 1970

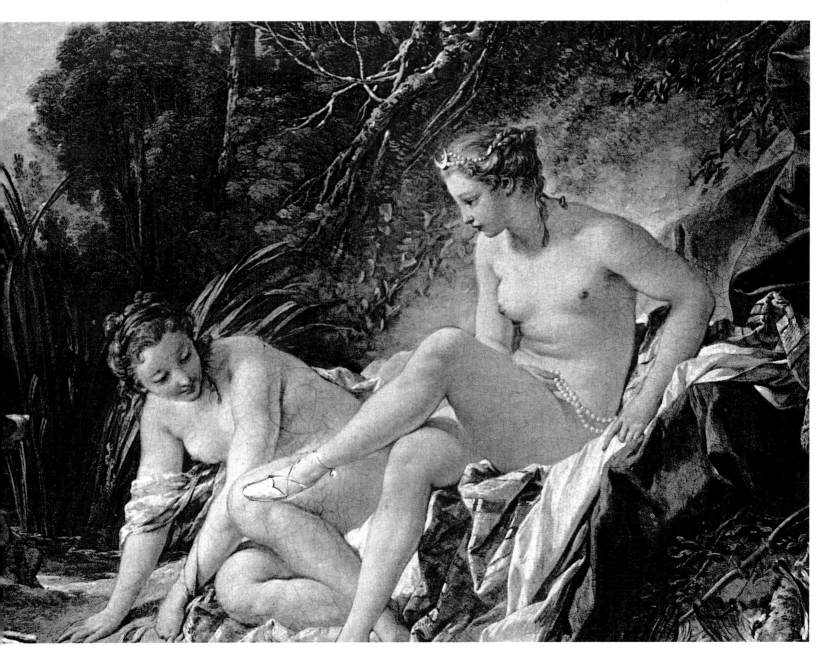

Shoes reserved for the powerful

and dignitaries:

the bright polychromies

THE SHOES OF THE JAGUAR

and the essential lines

of the art of the Maya

inspire a

contemporary designer

P oster of the exhibition
'The Maya' in Palazzo Grassi
from 6 September 1998
to 16 May 1999.
To the right and left
of the statue,
footwear by René Caovilla
inspired
by the ancient civilization
of Pre-Columbian America

How is an Idea born?

Invoked, pursued, the Idea has its timescales:

it likes to take you by surprise,

when there is not even a pencil at hand.

> Better to build a nest for it,

> to wait for it.

A sketchbook,

a notebook for notes and sketches

where ideas just born can lie,

fresh for the new inspiration.

This is the project taking shape.

Dior Collection, 1998

FAMILIAR GEOMETRIES

Around the twenties Giacomo Balla

designed a series of models

of shoes for his daughters,

Luce and Elica. Inlays of fabrics

or coloured leather composed forms,

tending towards the geometric or else

dynamic, which were sometimes painted

by the artist directly onto silk.

Giacomo Balla,
evening shoes, 1929,
painted silk.
Private collection, Rome

Study of woman's shoe,
1918–1920, black crayon
and water-colour on paper.
Private collection, Rome

Study of woman's shoe,
1928–1929,
black crayon on paper
(sheet from a sketch book).
Private collection, Rome

High-heeled shoe
by René Caovilla
inspired by Balla's geometries.
Photo Paola Buratto Caovilla

Form and colour, play and seduction, archetype and object of use, symbolism and materiality: these, and many others besides, can be the 'evocative' meanings of footwear. An intense and provocative 'aestheticity' which, probably, has always been at the basis of the designs and projects concerning their conception and realization. Every footwear item, especially in the cases where creativity comes most into play, is in itself a minor masterpiece. But we have the proof to affirm

that these provocative 'objects of desire' also perfectly trace the scenes of art as such.

The proof is simply the fact that footwear, especially in recent years, has become the

inspiration and subject for works of painting and sculpture. Interpreted in figurative or surreal, conceptual or dadaist terms and, above all, the protagonist of some impor-

tant works of Pop Art, the extraordinary expressive formula with which Andy Warhol became famous. And, on

this subject, it must certainly be recalled that the young Warhol began his career as a designer of shoes...

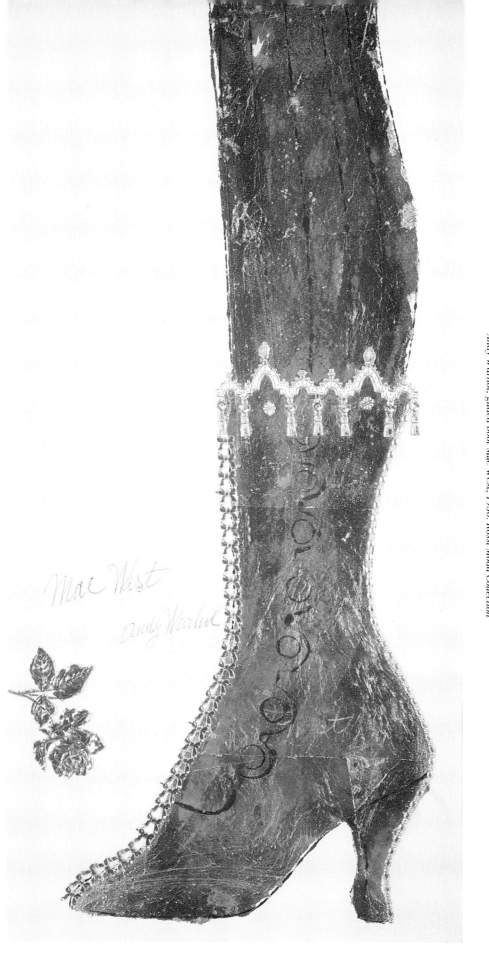

Andy Warhol,
gilded shoe Beatrice Lielie,
1956

Gilded shoe Margaret
Truman, *1956*

Shoe Jean Vaughan, *1956*

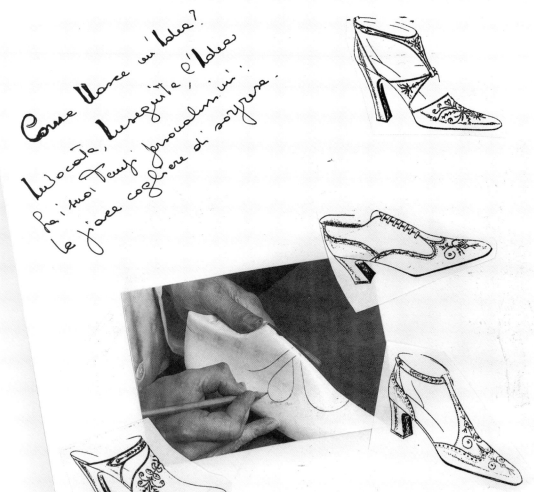

Come nasce un'Idea?
Individuata, inseguite, l'Idea
fai i tuoi tempi provali in vi :
le giace cogliere di sorpresa.

THINKING THE IDEA, THINKING LO[W]

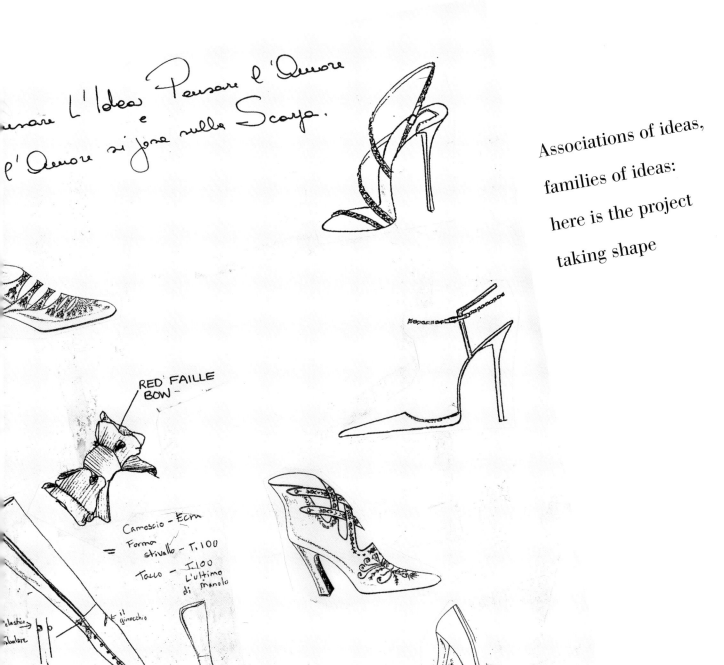

Pensare L'Idea Pensare l'Amore
e l'Amore si fene sulle Scarpa.

RED FAILLE
BOW

Camoscio - Ecm
Forma
stivallo - T.100
Tacco - T.100
L'ultimo
di Manolo

elastico
tubolare

il
ginocchio

Picaparto
pelle

Il modello
troppo
alto.

Associations of ideas,
families of ideas:
here is the project
taking shape

E, AND LOVE RESTS ON THE SHOES

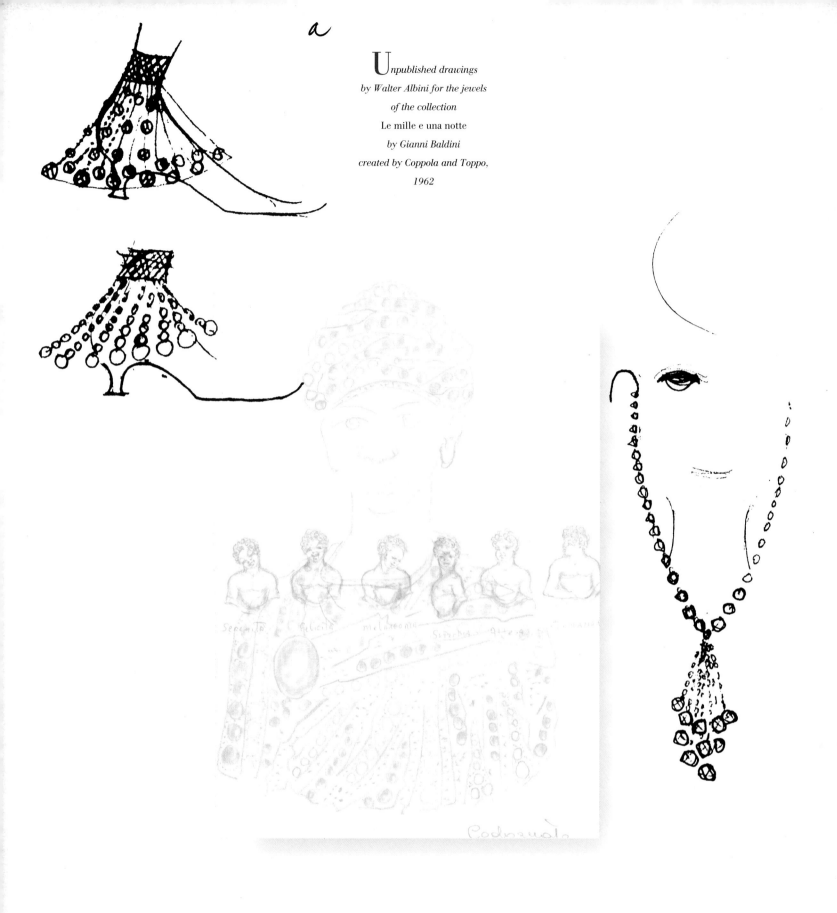

a

Unpublished drawings
by Walter Albini for the jewels
of the collection
Le mille e una notte
by Gianni Baldini
created by Coppola and Toppo,
1962

Bold subtleties, 'out of place' objects for the embellishment of the foot, slipped downward from 'nobler' seats. Seduction is also Revenge.

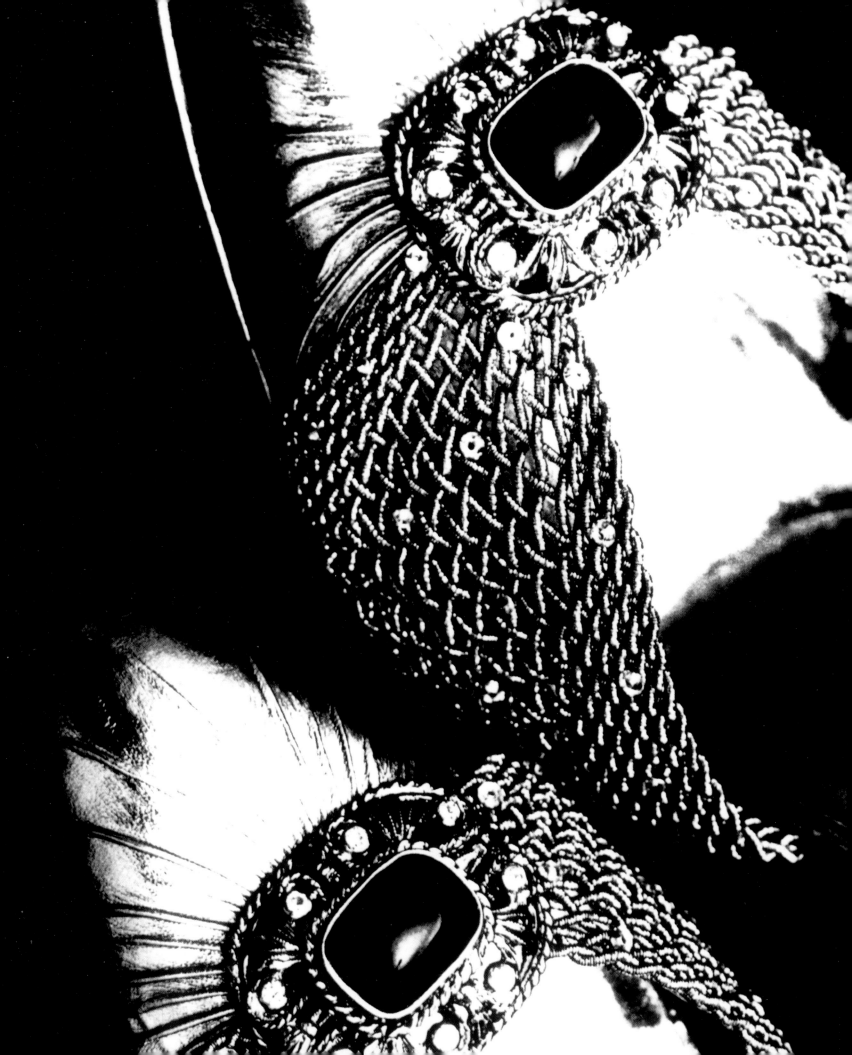

A cameo on an ankle? A brilliant on the big toe?

Why not? Seduction is sensual

originality, stimulus for the senses and the mind.

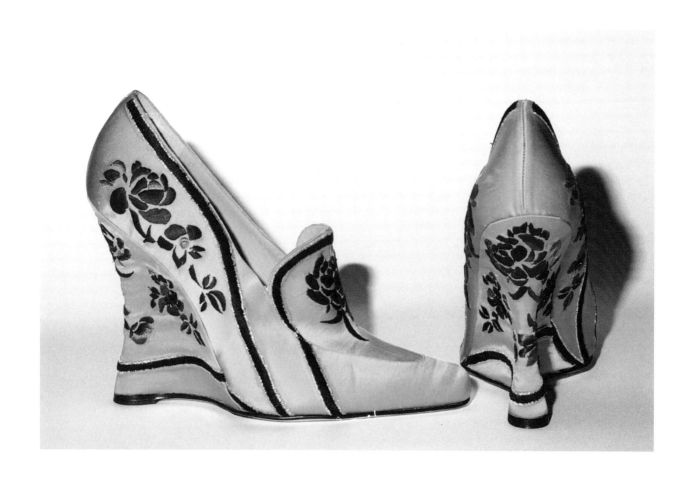

Model
created by René Caovilla
for Christian Dior, 1998

o hold a shoe in the hands

is to hold in the hands

hours of commitment of men and women:

hours of their lives dedicated to us.

From the idea to the design,

to the fitting, to the model,

to the realization:

following the genesis of a shoe is an emotion,

and imagining how many people have worked on it

makes it an even more friendly and precious object.

Yet we are too accustomed to no longer asking ourselves

the reason why things are. And how.

Objects of such common use

that we no longer know how to look.

Looking at a shoe is appreciating a silent work:

it is a stimulus to move closer

also to other products

with new eyes, with the curiosity of a child

who wants to know who has invented

houses, the motorbike or cheese,

wine; and shoes.

Industrial production that still has the aroma

of craftsmanship, of manual workmanship, of attention to detail.

1751 @ 24 May

1751 @ 9 9bre

638

Forms and colours

are offered on a palette awaiting

a hand and a mind,

ready to accept ever new

and unexpected suggestions

a hand and a mind

64

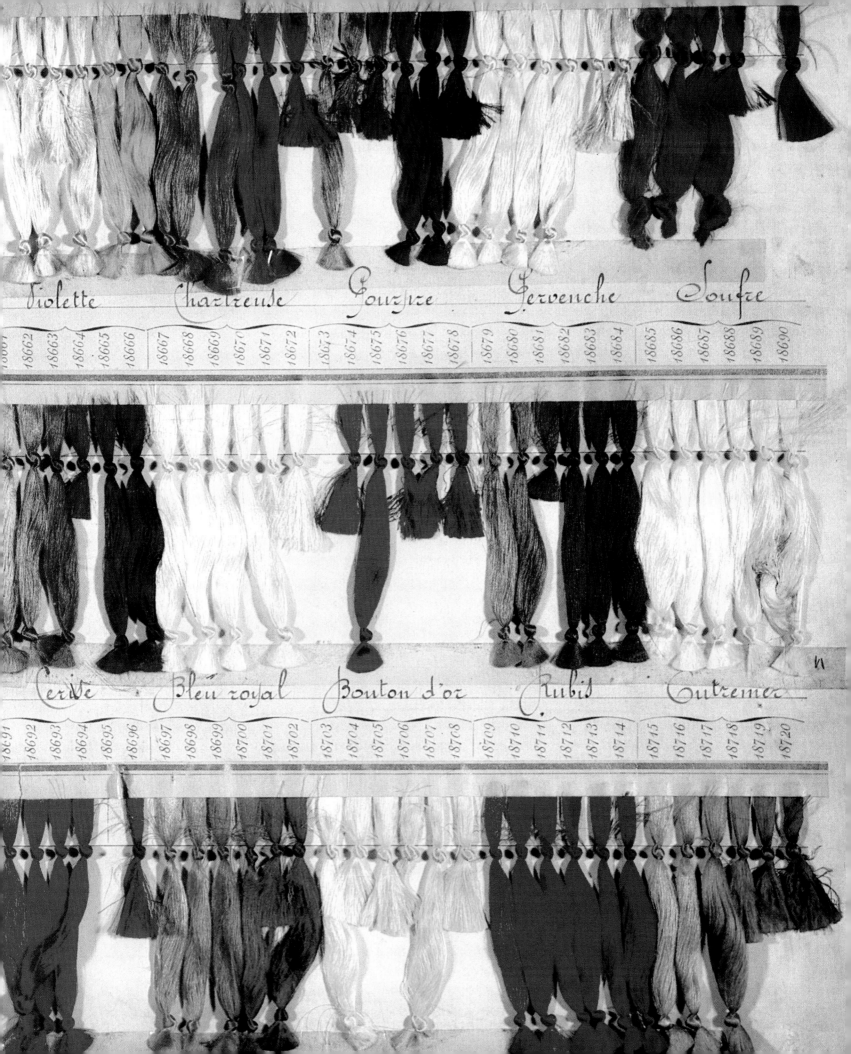

| Violette | | | | | | Chartreuse | | | | | | Pourpre | | | | | | Pervenche | | | | | | Soufre | | | | | |
|---|
| 18661 | 18662 | 18663 | 18664 | 18665 | 18666 | 18667 | 18668 | 18669 | 18670 | 18671 | 18672 | 18673 | 18674 | 18675 | 18676 | 18677 | 18678 | 18679 | 18680 | 18681 | 18682 | 18683 | 18684 | 18685 | 18686 | 18687 | 18688 | 18689 | 18690 |

n

| Cerise | | | | | | Bleu royal | | | | | | Bouton d'or | | | | | | Rubis | | | | | | Outremer | | | | | |
|---|
| 18691 | 18692 | 18693 | 18694 | 18695 | 18696 | 18697 | 18698 | 18699 | 18700 | 18701 | 18702 | 18703 | 18704 | 18705 | 18706 | 18707 | 18708 | 18709 | 18710 | 18711 | 18712 | 18713 | 18714 | 18715 | 18716 | 18717 | 18718 | 18719 | 18720 |

There are shoes spiteful as a corset

 or vain as a primadonna,

or innocent as a child.

 Impudent shoes, well-bred shoes,

wise shoes, madcap shoes,

 falsely ingenuous shoes.

Shoes that contain the soul of a woman?

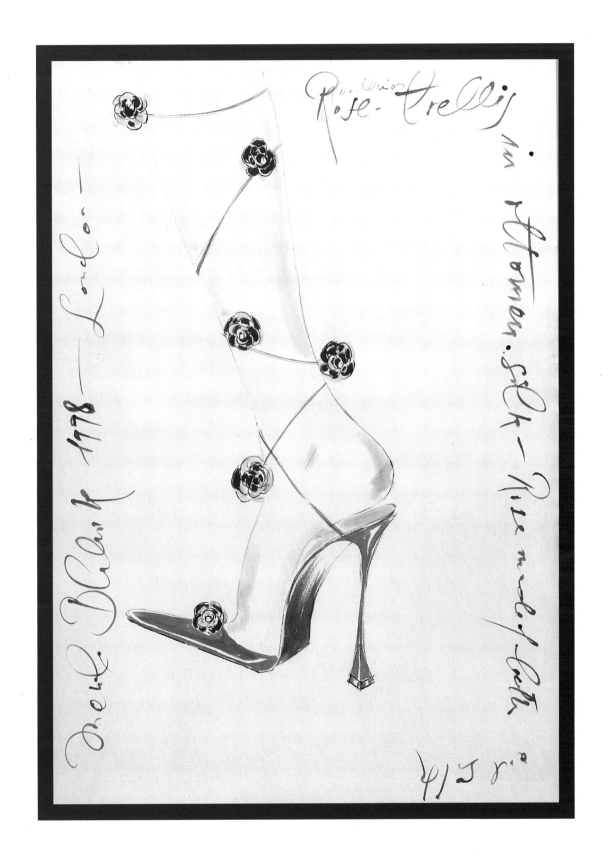

67

HEARTS

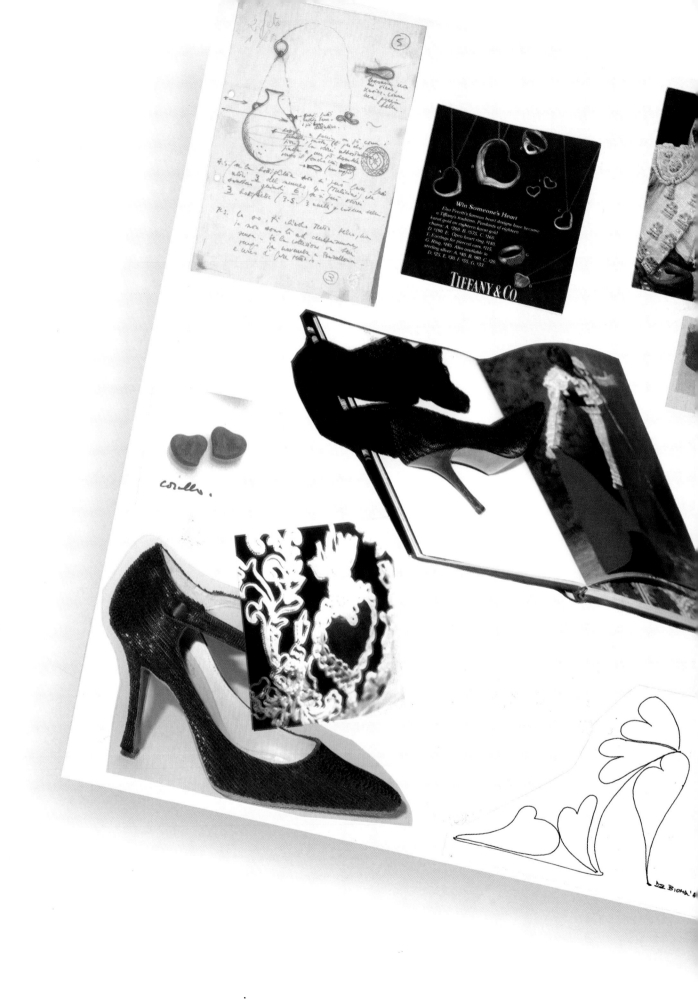

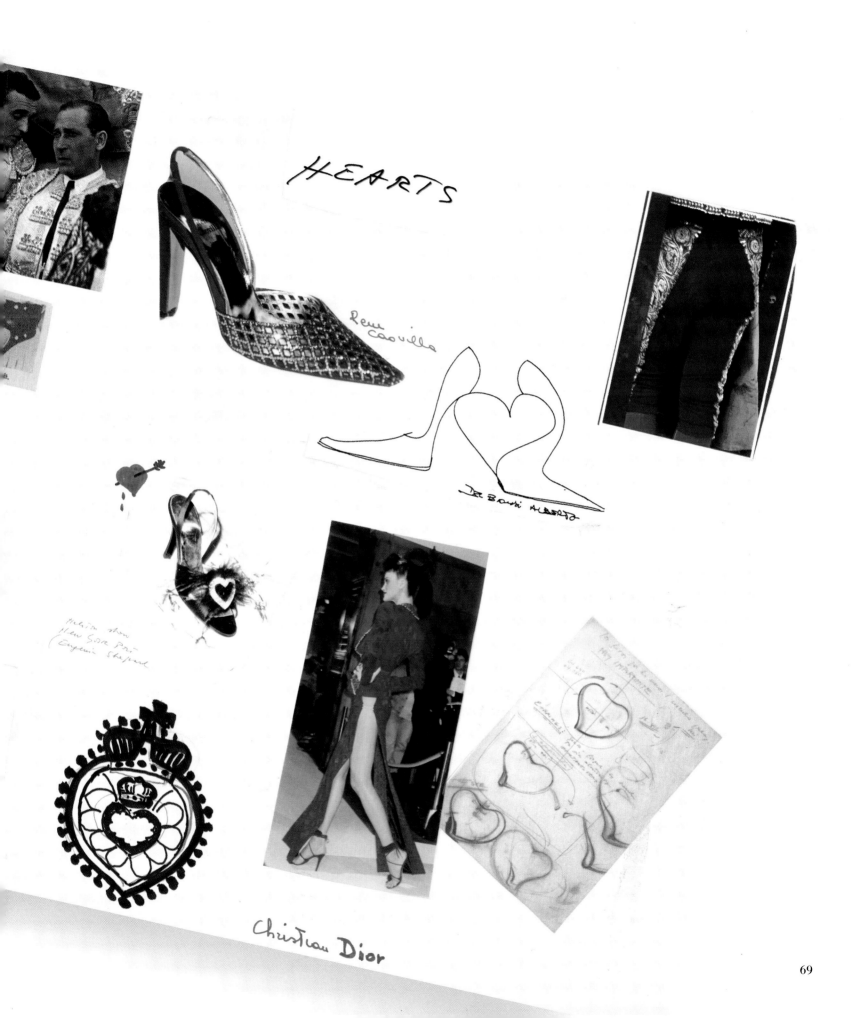

HEARTS

Reue Caovilla

De Bondi ALBERTO

Christian Dior

69

Endless shades and degrees of colour which, shown on a shoe, become instantaneously of a season, of a place: the souvenir of time and space.

An immense reservoir offers itself to invention: those who love their own world dare to look around.

The lesson of the classics: nature is the prime inspiration.

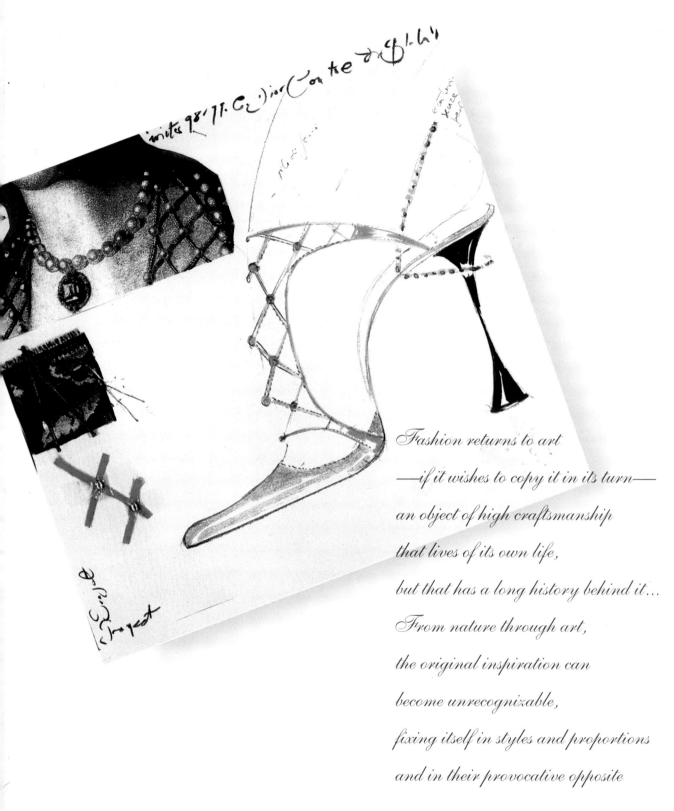

Fashion returns to art
—if it wishes to copy it in its turn—
an object of high craftsmanship
that lives of its own life,
but that has a long history behind it...
From nature through art,
the original inspiration can
become unrecognizable,
fixing itself in styles and proportions
and in their provocative opposite

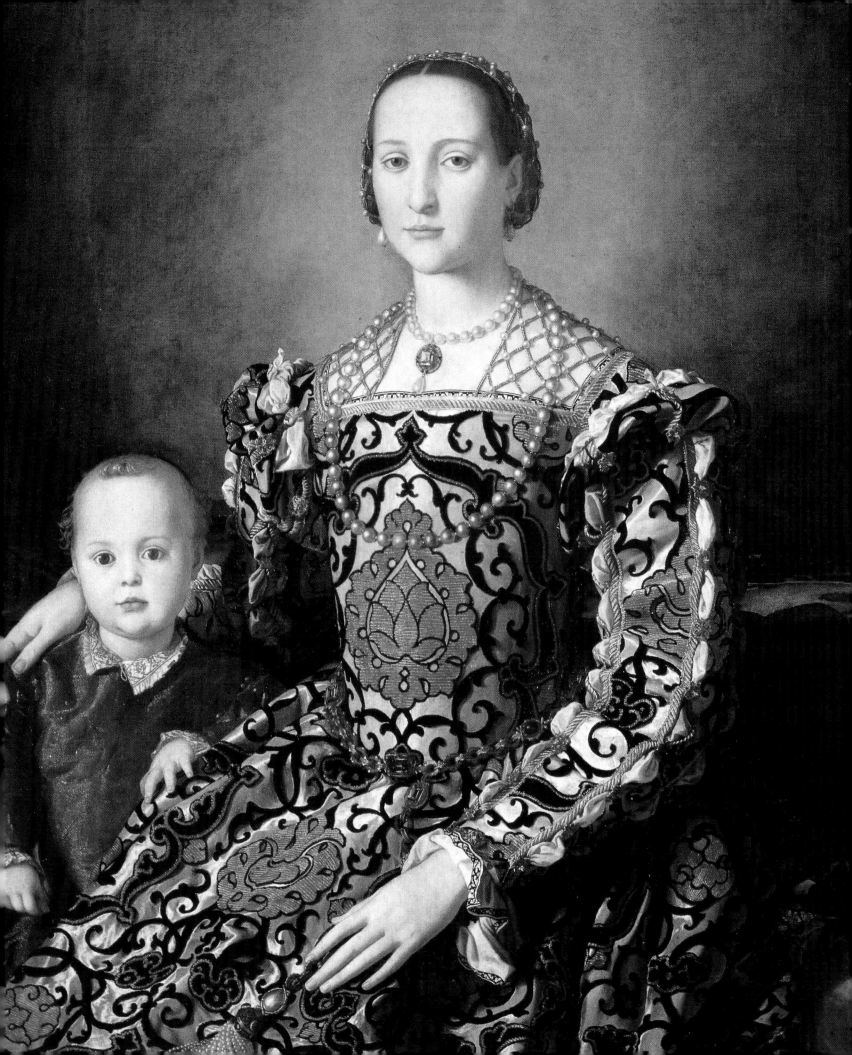

The search for 'ethnic' seduction,

the search for the roots

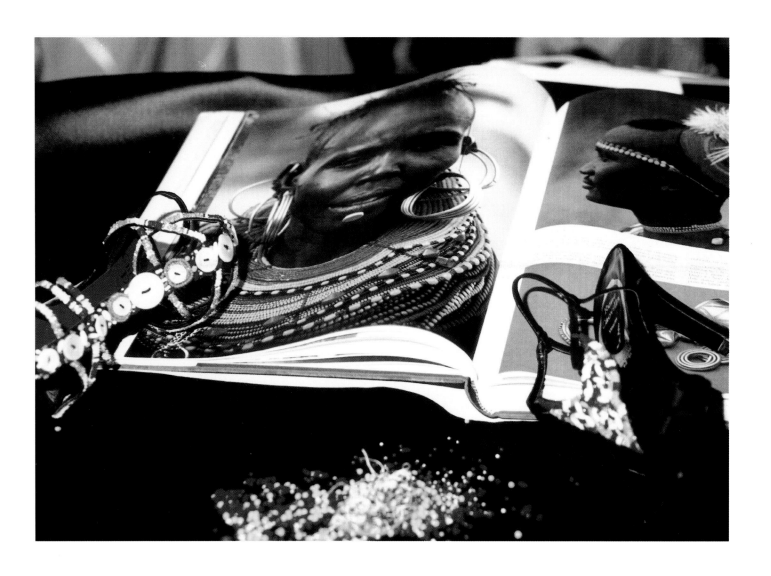

'ETHNIC' SEDUCTION:

NEW INSPIRATIONS,

SECRETS AND MAGIC TO BE DISCOVERED AND IMITATED,

ADAPTING IT TO THE TASTE OF A WOMAN

WHO LIVES HER OWN TIME

HERE AND NOW.

ALSO IN ART AND IN FASHION

CURIOSITY PROMPTS CULTURES

TO EXCHANGE NOTES, TO CROSSBREED.

A RECIPROCAL ENRICHMENT.

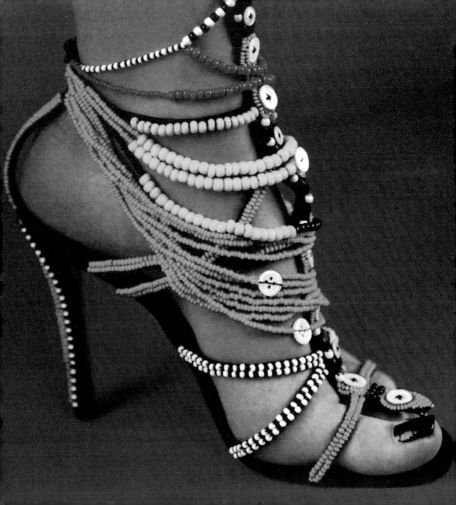

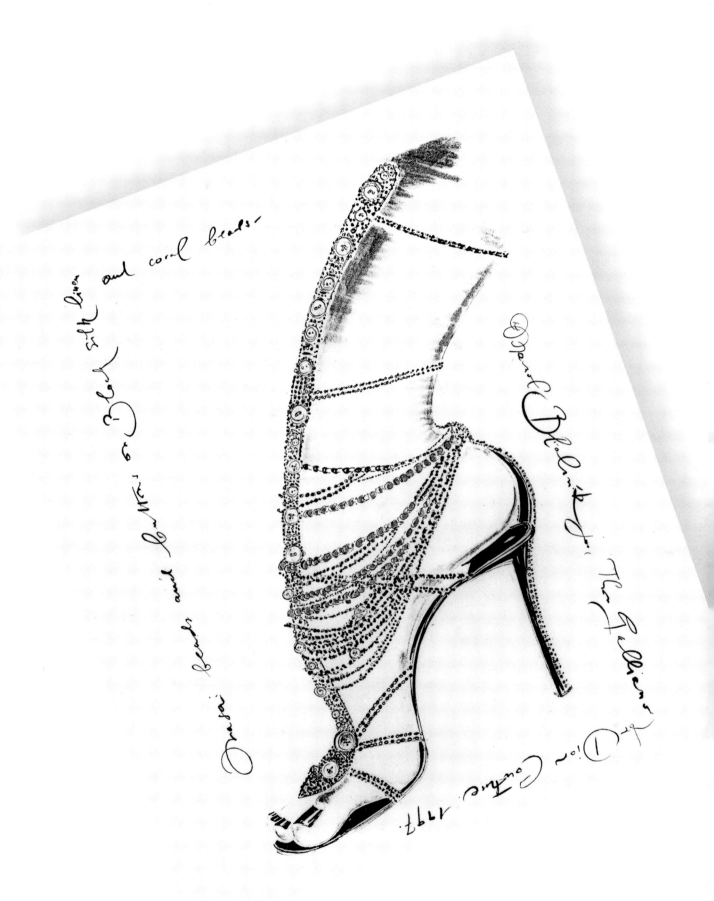

and coral beads—

Black silk linen

Gucci beads and buttons or

Manolo Blahnik The Fellini's to

Dior Couture 1997.

①

Bodies to t

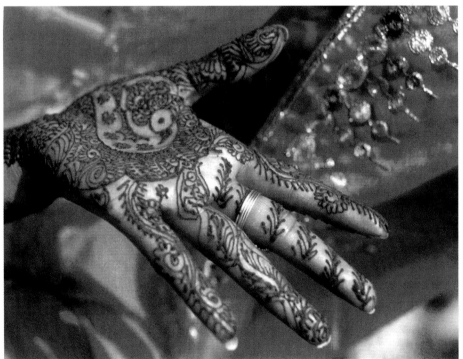

Henna decorations,
ephemeral tattoos
destined to be
continually
renewed to renew
the attraction
of the body.
Coded messages
colour of the earth,
that a shoe
inspired by them
can render eternal.

Seduction
takes on different
faces and guises
among peoples.

e designed

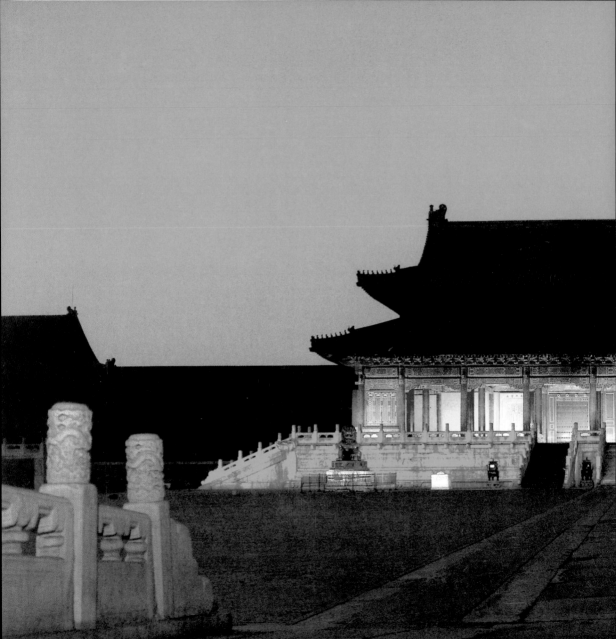

The forbidden City.
Ancient Chinese footwear
inspired
this model by Dior

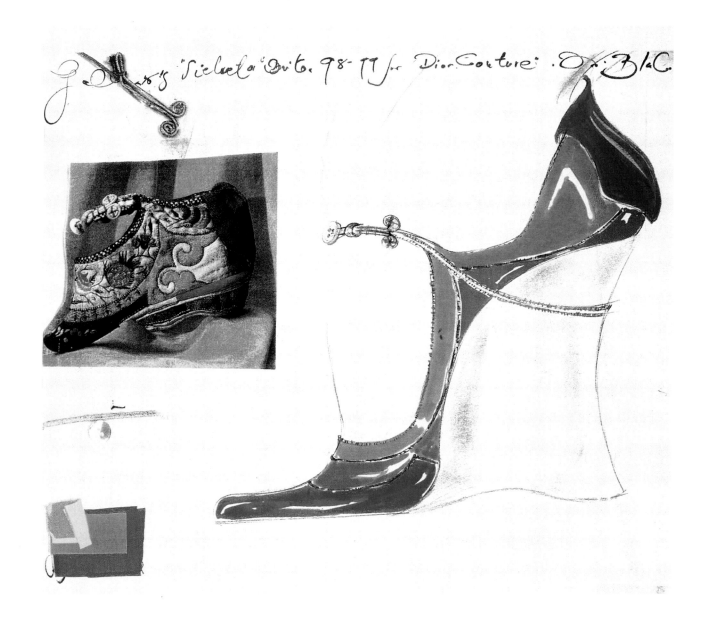

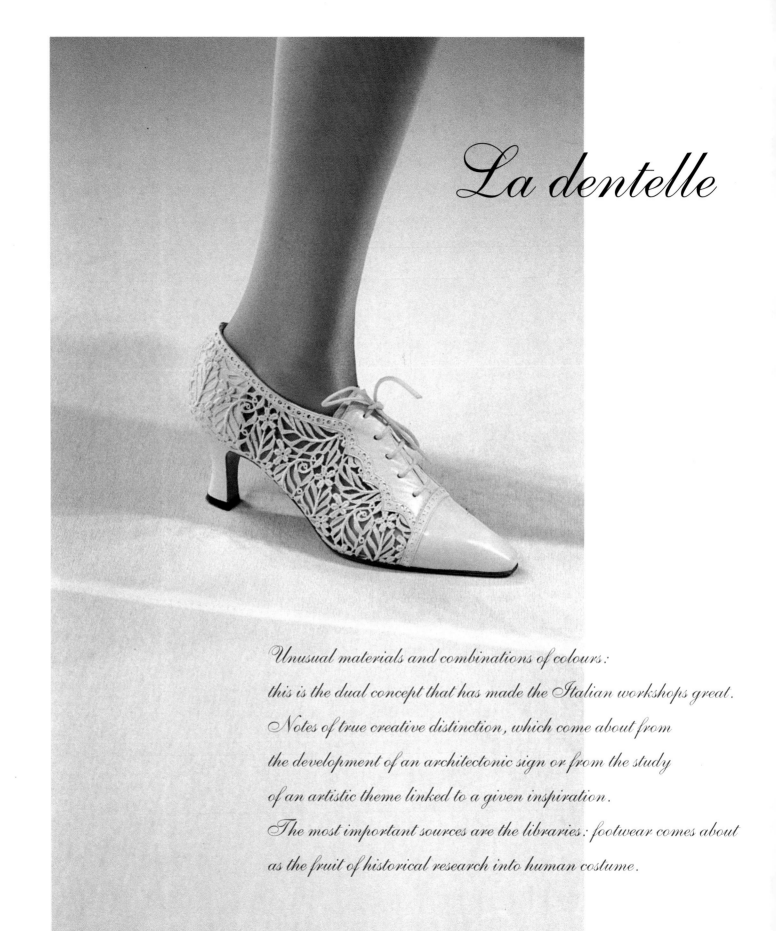

La dentelle

Unusual materials and combinations of colours:
this is the dual concept that has made the Italian workshops great.
Notes of true creative distinction, which come about from
the development of an architectonic sign or from the study
of an artistic theme linked to a given inspiration.
The most important sources are the libraries: footwear comes about
as the fruit of historical research into human costume.

Burano Museum

Drawing by Clauco B. Tiozzo

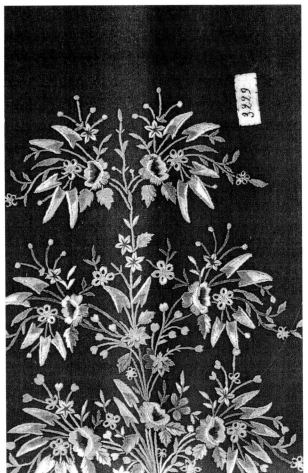

Hand-embroidered fabric. France, eighteenth century

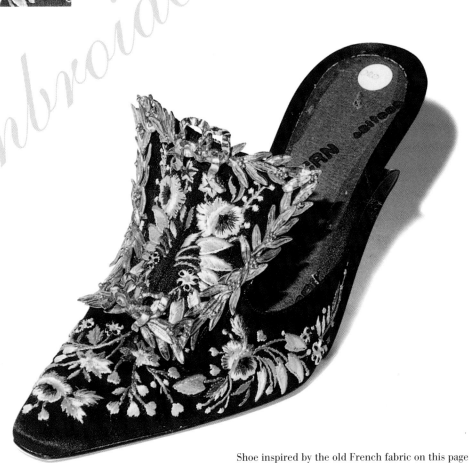

Shoe inspired by the old French fabric on this page

FASHION BUILDS TEMPLES

TO THE CREATIVE SPIRIT,

CONSECRATES THE PROPHETS OF STYLE,

OF SEDUCTION.

Class par excellence.

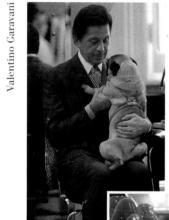

Valentino Garavani

The obsession with red and black.

But everything is permitted to 'red Valentino'.

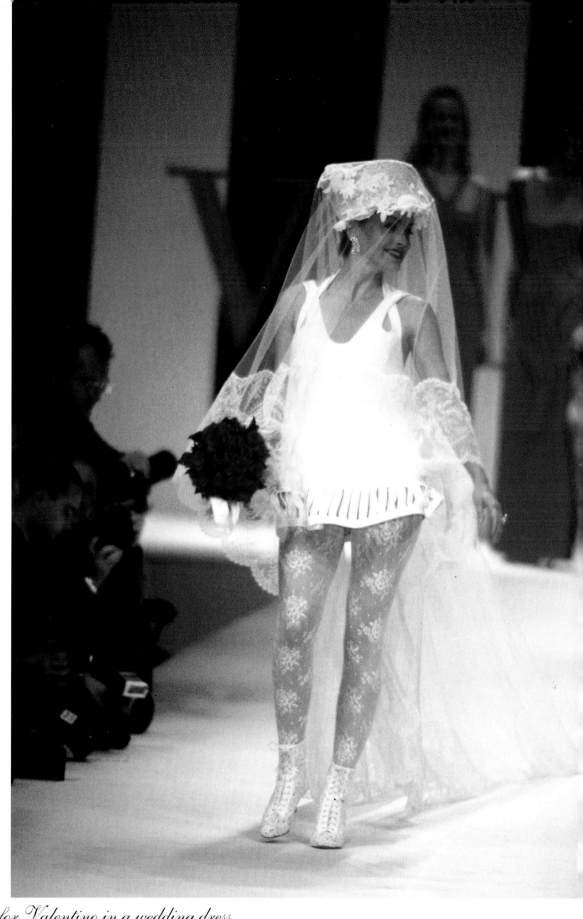

Sharon Stone on the catwalk for Valentino in a wedding dress

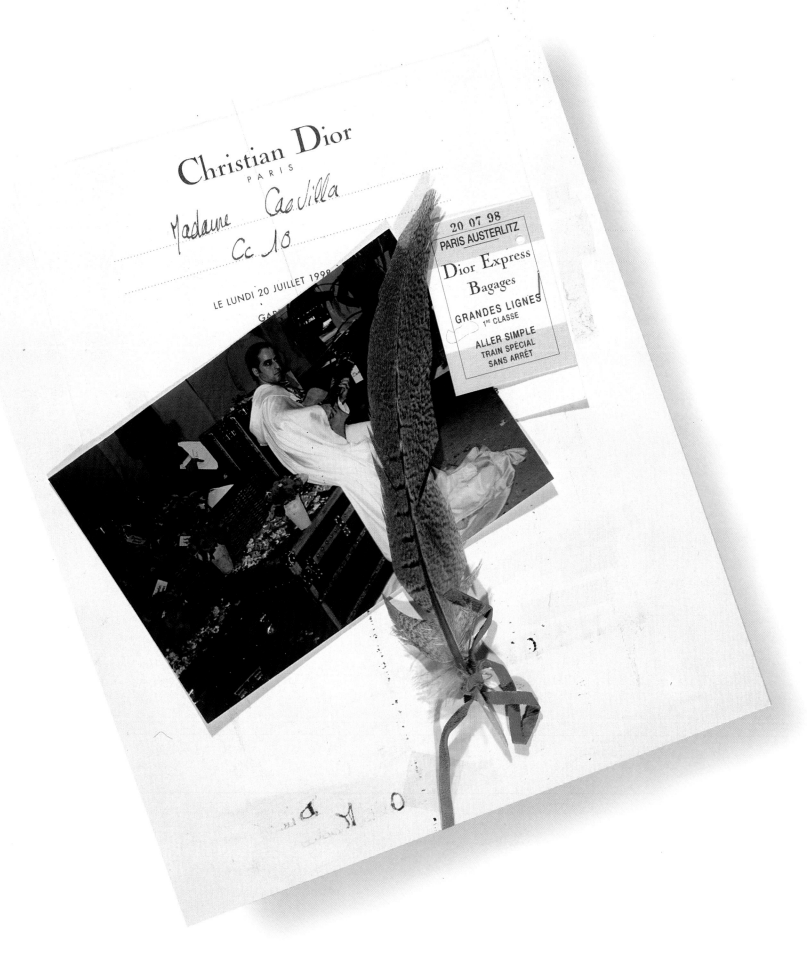

Parading amid rose petals,

and on red earth that covers with dust

maniacally perfect shoes,

between desecration

and invention

JOHN GALLIANO

Cinderella for an evening,

dreaming of the prince

Joys and obligations of the limelight: the pleasure and 'duty' of being beautiful, talented, perfect. Among the divas—and not only—there are those who hang on to 'good-luck' garments and shoes. Superstition? Perhaps. But also affection for and gratitude to objects that have accompanied encounters with their dreams, contributing to making them feel at ease, to fitting into character, to being themselves: to offering the best of themselves.

The most beautiful shoes in her life:

at least as important for the bride as her gown,

even if she wears them for just a day.

Symbol of sensual harmony,

of youth, prosperity, fertility, femininity:

the bride's shoes are all these...

Shoes that are the protagonists of the propitiatory rite

accompanying the bride and groom

towards the honeymoon and a life together.

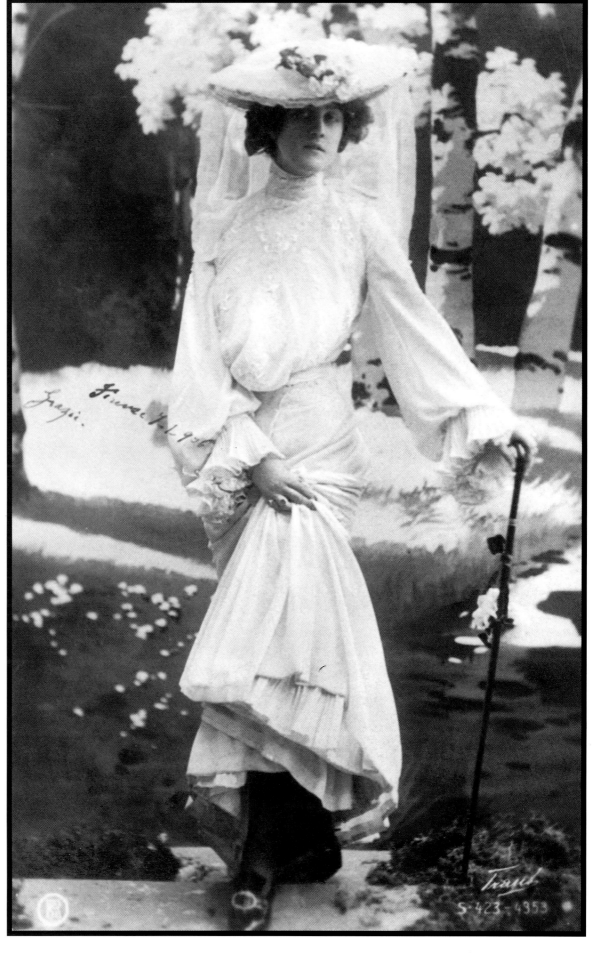

Shoes for a day

Les contrastes à la mode; ou le petit soulier de la duchesse cédant à l'ampleur du pied du duc. Dessin humoristique de James Gillrary, 1792.

BRIDES BEGAN wearing white slippers with their gowns in the mid 19th century—a tradition still observed today. Peter Fox's fantasy-filled line of wedding shoes (facing page) is ultra-feminine, with narrowed heel and toe.

La sposa xe felice fin ch'el tajer sa da torta. (21)

El maridarse no xe per tuti,
chi vien bei e chi vien brutti.

La bela dote,
marida anca le zote.

El matrimonio xe bon per i boni. (4)

Questo è effetto d'Amore,
il formar di due cuor
un solo cuore.

L'omo maridà g'ha quattro p:
pene, pensieri, pentimento, e penaci.

Chi se marida zoveni,
no porta braghesse da veci.

My women's footwear

that coquettishly

peep from under the skirts

at coverings of noble bases

of two rising columns

charged with lithe and age-old harmonies

and all else that is mysterious and soft,

that is silent here,

are the object of my attentions;

they whirl in my mind and my heart,

they are my dreams: to make people dream.

They are made with skill: to make themselves loved;

with so much love

I offer them to Gentle Ladies

of every place, of every kingdom.

Clauco B. Tiozzo

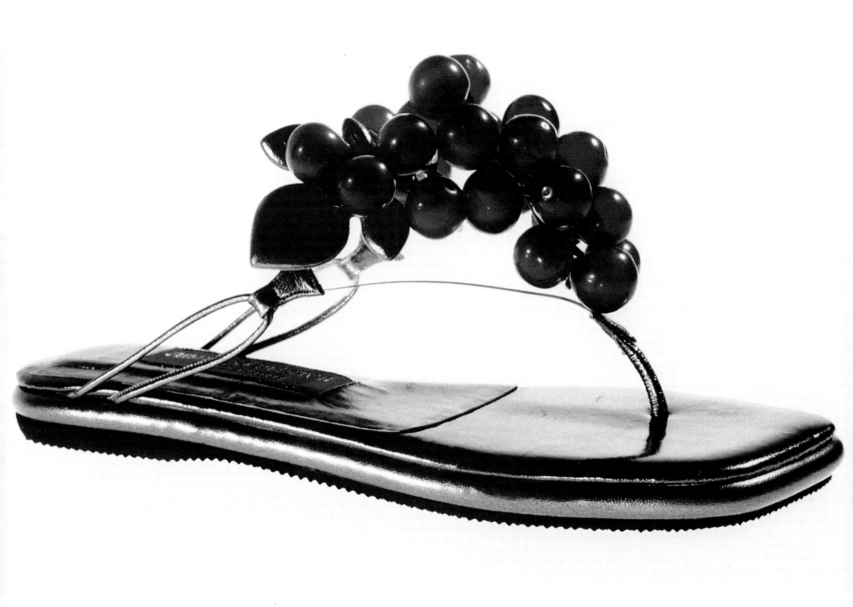

A GOBLET OF WINE: THE MATCHLESS ACCOMPLICE OF EROTIC MERRIMENT

Drawing by Jean Cocteau

Les plantes et les animaux
Nous enseignent notre ligne
Lorsque tu plantes ma vigne
Je récolte le vin des mots
 Jean Cocteau

Scarpe e vino: scarpe e natura viva
tornano ad incontrarsi.

Rothschild Collection

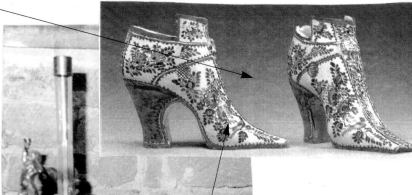

Pair of shoes used as glasses.

Delft multi-coloured ceramics,

late seventeenth century.

Shoes and Wines

Scarpe da Gustare!
Bere Vino dalle Scarpe
dell'amata, e in Pubblico,
è la più forte dichiarazione
d'Amore!

E l'amante, un po' brillo,
si lascia andare alle parole più ardite,
magnificando quei piedini...

Del Biondi Alberto

SHOES AND WINES

Nature is a temple whose living pillars

sometimes emit confused words;

man passes there amid forests of symbols

that observe him with familiar gaze.

Like long echoes that merge far away

into a tenebrous and profound unison

vast as the night and as the light of day,

the perfumes, colours and sounds answer each other.

There are perfumes fresh as a child's caress

sweet as the oboe, green as the grasslands,

and others, corrupt, rich and triumphant.

They have the expansion of endless things,

like amber, musk, benzoin and incense,

which sing the transports of the soul and the senses.

Charles Baudelaire, *Correspondences*

Earth. Water. Air.

And the fire of the sun.

This you will breathe.

And grass, leaves and fruits,

Flowers in your path.

I would like you to meet this.

The wind will lift your skirts

purposely to play with you.

Run, if you wish.

But wait for me.

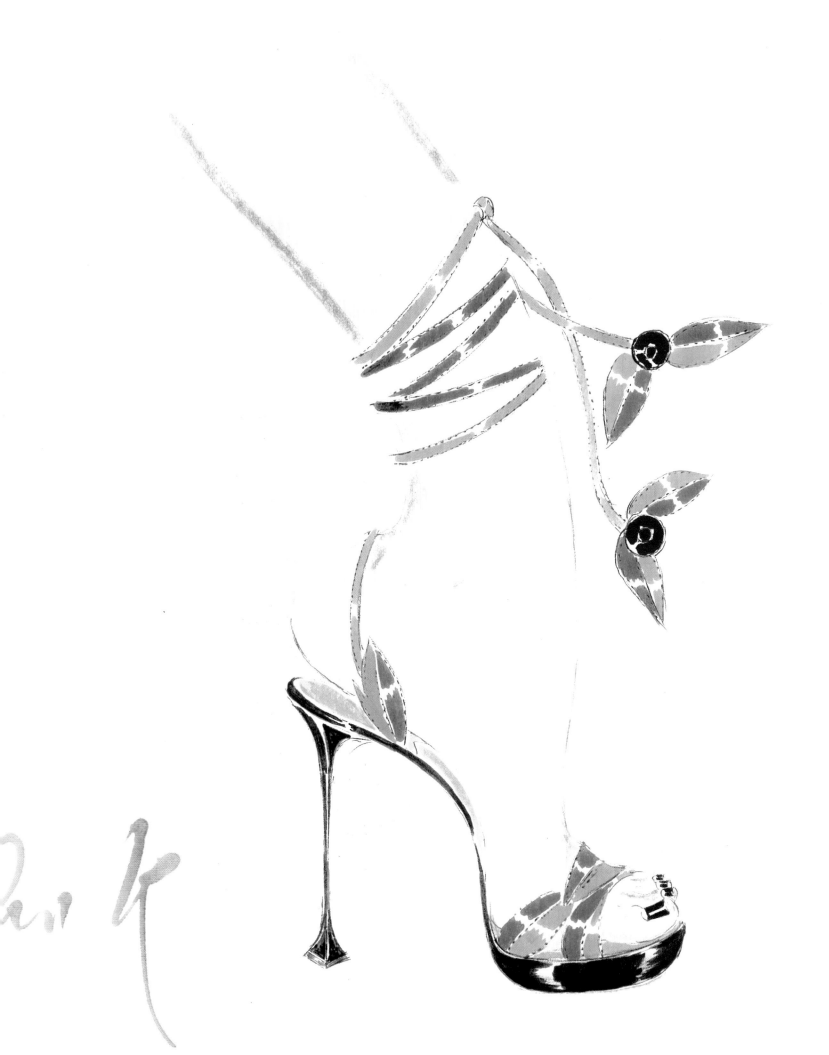

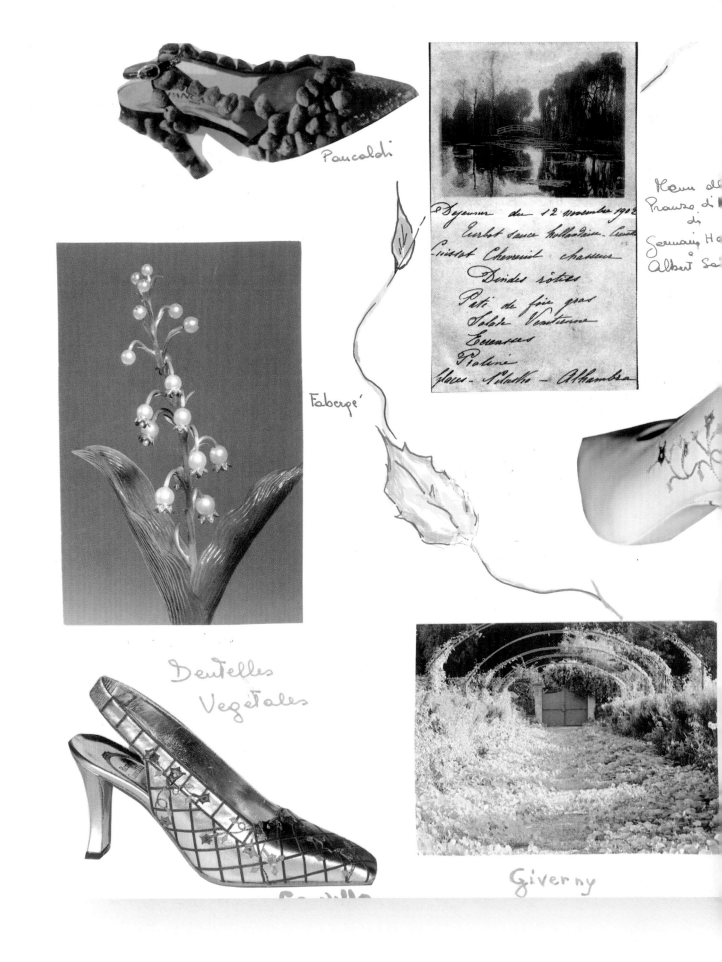

BOTANIC COUTURE

Pancaldi

Fabergé

Dentelles
Végétales

Giverny

Botanic Couture

cabinet de Verdure

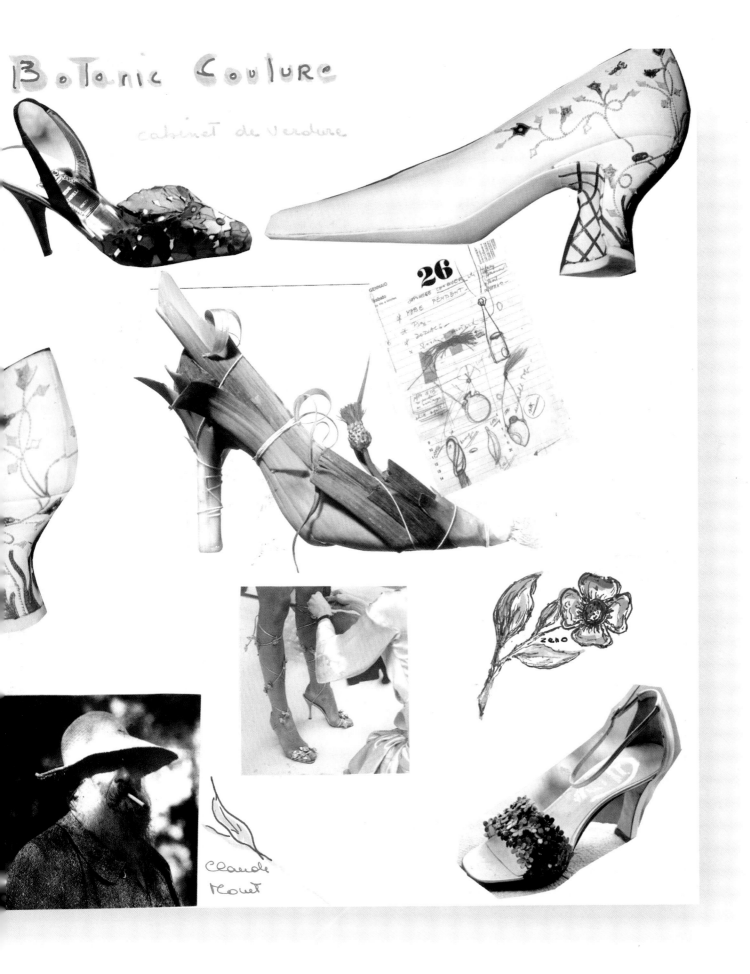

Claude
Monet

Mirroring ourselves in an illusion to rediscover the truth:

ourselves

Magic seduction of the theatre,

representation and mask of life.

Each show is a debut.

The shoes are also made to infuse the courage

to return to the stage, like the first time

L'ATELIER
dell'illusione

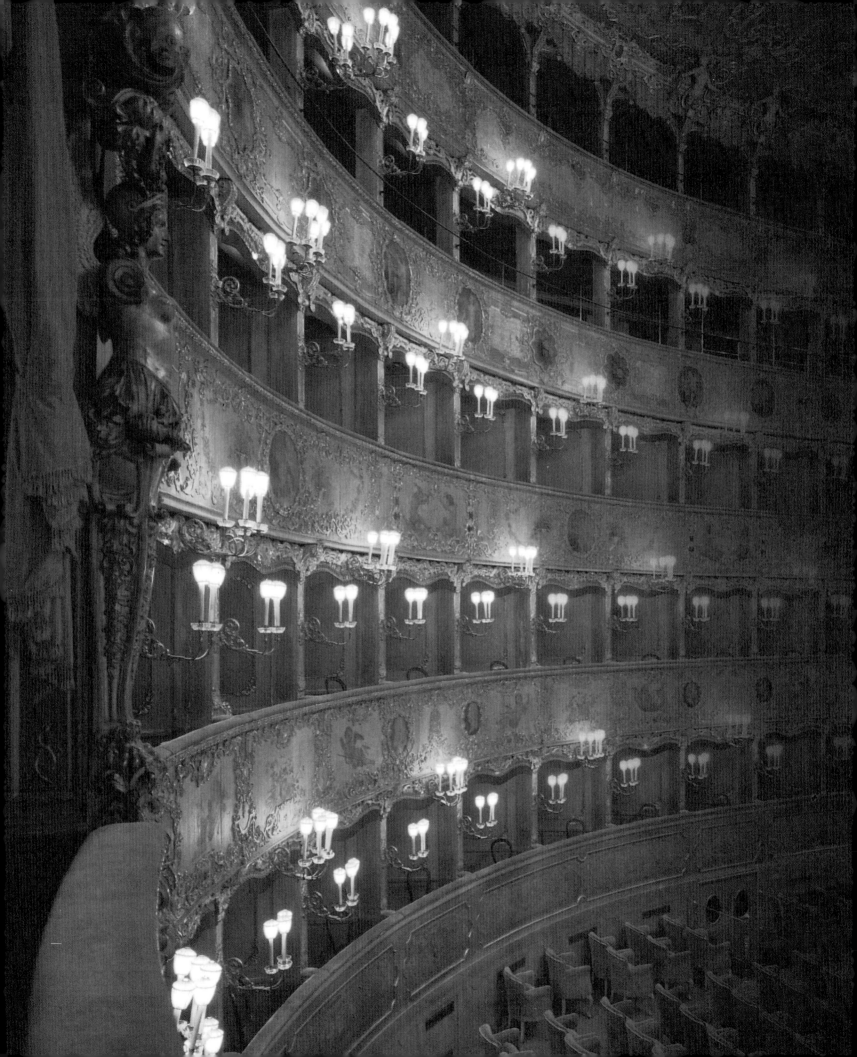

La Fenice shoe, Christian Dior Collection

Preparatory sketch for the costumes of *Così fan tutte* by Wolfgang Amadeus Mozart

Score of *La Traviata* sent by Ricordi to La Fenice, 1853

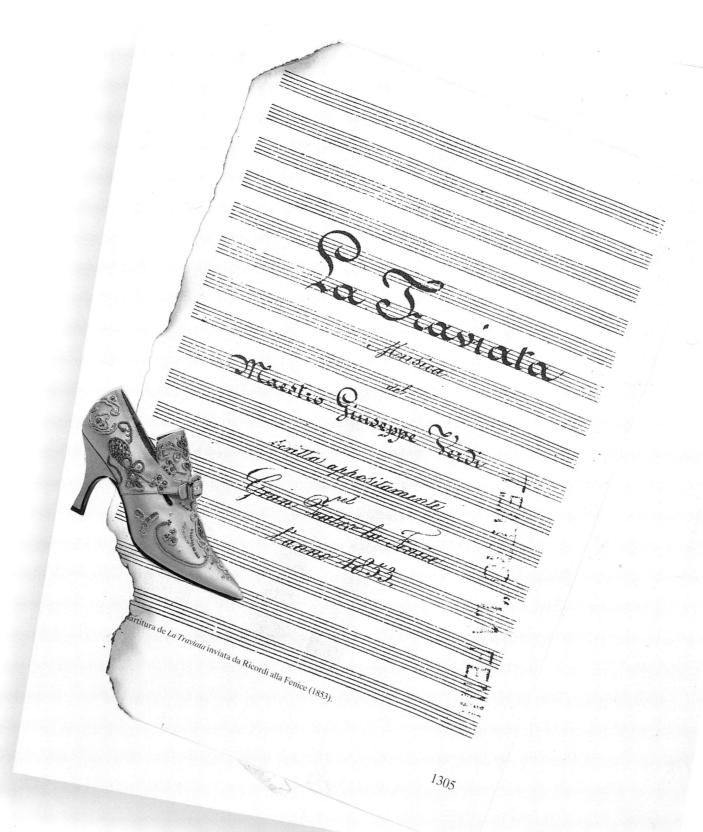

Partitura de *La Traviata* inviata da Ricordi alla Fenice (1853).

1305

FROM THE HEAD TO THE TOES

Maurizio Scaparro

If I had to choose, in the infinite game of seduction, I would personally start with the head, and the imagination.

It is a premise that also serves to arrive at the foot, which, in the game of seduction, has often had a far from secondary role.

In theatre, as in literature and life, the head has often made the foot act wisely, I believe ever since the origins. If anything, the more we are 'civilized' by the arts and literature, the more we feel the need for the reflected, rather transversal, slightly ambiguous mediation—taking the place of direct seduction—of two hands brushing past you, of the whispered word 'I love you', of the first kiss.

For the 'civilized', the right time for the foot also arrives.

A foot, of course, that is shod with great elegance, so that the shoe can be taken off as the knowing and exciting beginning of a striptease, and so that the stocking can uncover the foot fantastically (or naturally) naked.

Or, precisely, naked, as the romantic spirit of Kleist (in the essay on the Theatre of the Marionettes) glimpses in the young man who, removing a thorn from his foot, takes on the perfection of the Grace.

While two people in love at first sight, facing each other before a laid table, exchange looks punctuated by greedy bites on turkey thighs (as in the stupendous sequence in the film *Tom Jones*), what is happening, between the feet under the table?

What equally desirous, frantic, nervous discourses start with the shoes, to finish where there is more or less the finish or the attempt to finish?

My theatrical experience this year with *Casanova* has of course strengthened my conviction of the route from the head to foot, discovering the pleasure of the great Venetian seducer (or seduced) in a game that builds up obstacles and veils to arrive at that essence, at that nudity that

1950, Museo Caovilla

in its 'simplicity' risks not being—for the 'civilized', as we have more or less arrived at being—seductive in itself but in the game of subtractions or additions that the head suggests.

Yet, wishing to pay homage to high seduction, I prefer to have recourse to another of my recent theatrical memories, to those *Mémoires d'Hadrien* in which Marguerite Yourcenar is able to grasp the moments that sublimely bring together civilization and nature, complexity and simplicity, even in the foot: 'I keep intact the memory of the sharp Spanish face of my mother, suffused with an inexpressible sweetness. She had the small tight-sandaled feet of the young girls of Cadiz. And that young faultless matron had the soft swaying hips of Andalusian dancers'.

1998

TEATRO STABILE DI ROMA

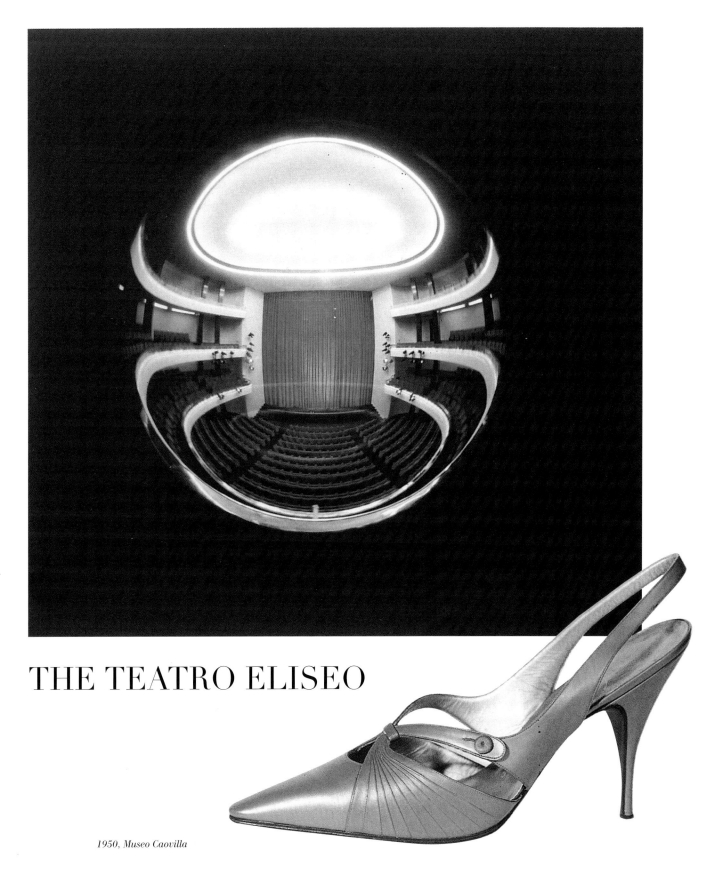

THE TEATRO ELISEO

1950, Museo Caovilla

THE ARENA IN VERONA

Photo Fainello

125

Even in dreams shoes leave a message. The Smorfia attributes precise meanings to them. Women's shoes will bring good luck in love, new ones announce coming into money. Felt shoes and boots promise serenity. What is the gift, if not a declaration in the form of an object? The small eighteenth-century style shoes, reproduced in silver or ceramic, constituted a welcome gift and a good-luck charm.

The sensuality of shoes is an invitation to love. Immediately after the ceremony, shoes are tied to the newlyweds' car in a sign of fertility: the wish for a numerous family soon to come. Thus the shoe becomes an affective symbol.

In history, the fantasy of man has always dedicated precious decorations to shoes. The worship of footwear was at the heart of the whole Renaissance; in the fifteenth century, in fact, luxury was to reach its peak: gilt and silver embroidered slippers, encrusted with pearls; Morocco leather, silk and velvet uppers.

Silver woman's shoe, Venice, private collection

Once submitting to my yellow and black shoe I was taken,

in such a way that I loved her more than myself

now I am the slave of my yellow and blue shoe.

Vincent Volture

Are shoes—like dreams—desires?

Shoes tell a story

Photo Paola Buratto Caovilla

They reveal who we are, what we do, where we come from and where we are going

To prefer footwear with particular

shapes and other simpler

ones is a clear symptom of the

fact that, indirectly, through the

object that is the shoe we are

attempting to satisfy the most

secret instincts in an illuso-

ry manner.

The choice of one shoe or

another always depends on

the emotiveness and affectivity

of the person who must wear it.

There are people—and so there are shoes—

Foto Paola Buratto Caovilla

that are not made for half measures.

They love, they live, they breathe as though it were the first and last day of their lives.

Each day the most beautiful day in the world. Each day the miracle of life. Each day the flowering of a passion.

Fetishism.

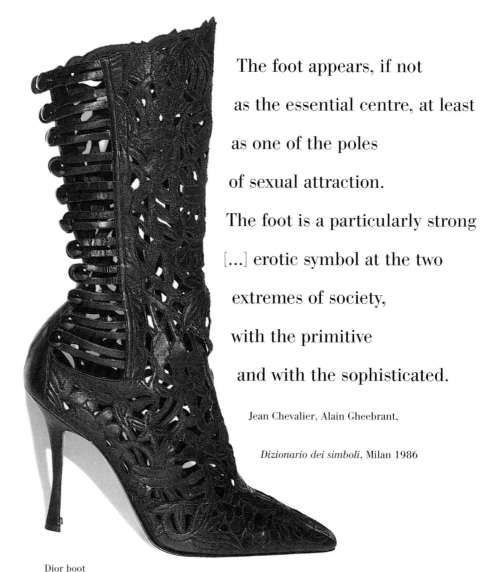

The foot appears, if not
as the essential centre, at least
as one of the poles
of sexual attraction.
The foot is a particularly strong
[...] erotic symbol at the two
extremes of society,
with the primitive
and with the sophisticated.

Jean Chevalier, Alain Gheebrant,

Dizionario dei simboli, Milan 1986

Dior boot

'She said she wore high heels for herself and for her men.

She said, and I quote again, that they made her feel,

"Potent, dominant and, oh yes, wet."'

Geoff Nicholson, Footsucker, *Victor Gollancz, London 1995*

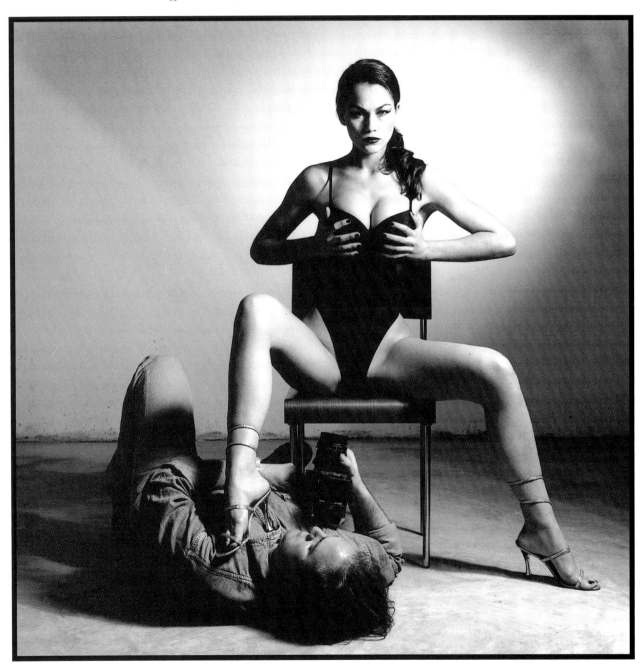

Photo Fredy Marcarini

Il Piede non è "un 'appendice" ma un Tutt 'uno con la gamba.

Scarpe per camminare scarpe per Esserci?

scarpe che promettono che Outraggiano

Del Biondi Alberto

Scarpe per farsi Amare
E forse un pò per farsi Odiare, e Detete,
Quindi per farsi Amare ancora di più

Vanessa Noel

De Biondi Alberto

Scarpe che promettono
scarpe che attraggono

Scarpe da accarezzare
da sfilare con sensualità

Claire B.

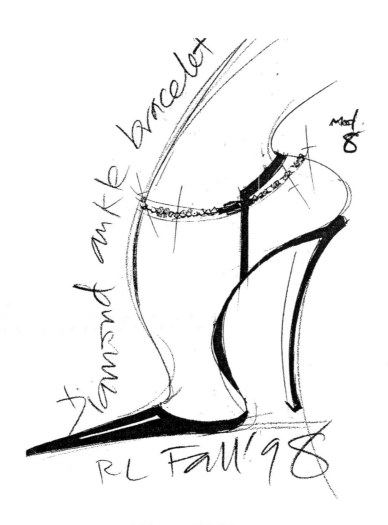

diamond ankle bracelet

Mod.
8

RL Fall '98

Ralph Lauren, 1998 Collection

Like all fanciful aptitudes, fetishism becomes a perversion when it is exaggerated: that is, when it becomes a solitary and mono-maniacal obsession. All men are keen on the sight of a delicate foot wearing an elegant shoe. But only those that are excited *exclusively* by this are abnormal. In reality, all of us have our own rather twisted erotic imaginations: a recent survey has revealed that half of women, at least once, have dreamed of tying up and whipping their partner, and the other half of suffering the opposite treatment. Even a vulgar word, said at the right moment, can be enjoyable, and a hint of pain often accompanies the inebriation of the embrace; just as, at higher levels, love evokes a subtle desire for death: Eros and Thanatos are brothers. But naturally no normal person loves being struck, or outraged, or dropping stone dead in the middle of an embrace. It is, as always, a question of degrees. But why, of all the objects and garments of fetishism, is the shoe the most representative, and most well-known? There are two theories, and we will state them with the appropriate degree of scepticism. The first is that footwear is, by definition, a container, and as such in man evokes the female organ. The introduction of the foot into the shoe would be the substitute for intercourse, rendered more exciting and perverse by the fact that it is the woman herself possessing herself. The unconscious transmission of desire from the man to the partner, which anticipates its satisfaction with a symbolic gesture. The second, completely opposite, is that the stiletto heel (the taller the heel the more powerful the fetishism) is the unconscious substitute of the virile member, which man reveres on the foot of a woman to disguise his own latent homosexuality: the male transfers this insane aspiration onto a more permissible object, because linked to the female body.

We do not know which of the two is correct: perhaps a little of both, and perhaps neither. The pretension to read into the human mind is quite

utopian, and the battle between the various psychiatric, psychoanalytic and neurological schools amply demonstrates this. Let us satisfy ourselves with knowing that, if they do not make it an exclusive object of desire, all normal people are favourably struck by a slim ankle, an arched foot and an elegant shoe. There is no need for recourse to nervous pathology. Perhaps the aesthetic consideration that the shoe lengthens, renders slimmer, raises, is sufficient. The stature of women has always been smaller than that of males, who have taken this as grounds for their superiority and dominion over them. But in each of us there coexist two souls: an *esprit de finesse* and an *esprit de géometrie*, feeling and rationality, weakness and strength, subjection and authority. It is not at all true that men claim that women are on an inferior level: they only do so when it suits them. Sometimes they want them on the same intellectual, sentimental and erotic level, and even something more. Footwear facilitates this restoration, and stimulates that masculine part that would like women to be their equal. Not only that. Every male has a latent tendency towards subjection. Without arriving at the paradoxes of masochism, it is true that man, more than woman, feels, every once in a while, the excitement of subordination. Perhaps he would like to restore an equilibrium compromised centuries ago, because man, in bed, has always been an unsatisfactory and rough dominator. When the

spark of this recomposition goes off, the male accepts a sweet and pleasant subjugation. All this it is a mental attitude, which has nothing to do with chains, whips, and the other ridiculous instruments of suburban brothels. It is a restoration of equality.

The shoe and the foot are the harmless instruments of this peaceful surrender.

Their admiration, well-mannered and discreet, is a pagan homage by the tempting snake to the woman that really binds him to the yoke of seduction. And if it is true, as psychoanalysts always teach us, that the reptile is a phallic symbol, religious iconography has often abused the biblical image, representing the Virgin with too sensual a foot to be the instrument of divine justice. In certain paintings, the demon succumbs too softly under Mary's heel.

And finally the shoe is the instrument of contrast with the apparent innocence of simple nudity. A naked woman can be the symbol of a virginal innocence; the nudity of *Lucretia* by Dürer accentuates the innocence of the violated young woman, who finds suicide to be the only instrument of rebellion; nobody could imagine her with stiletto heels. Now consider *Olympia* by Manet: her body is much more diaphanous than that of the sanguine Roman noblewoman, but everybody understands that she is debauched: the silk collar, the flower in the hair, the Negro slave girl, but above all the elegant shoes with gilded uppers. To be exciting, the nudity must be tempered.

All these considerations, of course, are simple hypothesis. The mystery of seduction does not reside in objects, but in the minds of those who send and receive a message that is always different and eternally the same. But the soul would remain confined in the world of Platonic ideas if it did not express itself through tangible representations, which acquire vitality through the way they are perceived. The most sado-masochistic fetishistic shoe is a harmless, even ridiculous knick-knack, if the person wearing it does not transmit a lash of seduction with the brain. As with all objects, it also only acquires a meaning through our imagination, our emotionalism and our fantasy.

'Swathed feet represent the highest sensual refinement of the Chinese. As well as the female walk, man began to adore the legs, to admire them, to sing them, he made them a fetish of love. Night slippers occupy an important place in all sensual poetry'.

Judging by the words of the Chinese scholar Lin Yutang, the origins of the adoration of the female foot and its footwear have supposedly been lost in the mists of time. Freud describes the foot as the infantile symbol of the virile member, and footwear as a female symbol, since the foot must fit it: the foot, in fact, entering the shoe, mimics a kind of penetration.

The fantasy of receiving violence from a woman sheathed in a leather suit with six-inch high heels reveals, in a man, how fragile the boundaries between the established sexual roles can be: it is a total overthrowing of the traditional view, whereby the male is in a position of domination over the woman, and, if is true that the heel is a symbol replacing the male organ, this desire is also an indication that nature (with its complexity and contradictions) prevails over culture (codification and reduction to standard behaviour).

On the other hand, we must also reflect on the exceptional peculiarity of the attitude of fetishists, who direct their desire towards an inanimate object, and, in the case of foot fetishists, one that is cold, unnaturally smooth, as is a heel or an upper.

The foot symbolizes our adherence to the ground: the higher the heel, therefore, the more the worshipper of the shoe detaches himself from his element, raising himself to a condition of suspension, ambiguous by its nature, not belonging to one place or another. Those who love

Fetishism. Sexual perversion in which a magic and inanimate object that is part of a person (clothes, feet, hair, etc.) exercises a sexual meaning, in the absence of which the subject is incapable of sexual arousal [...]

Caterina Fischetti, *La psicoanalisi infantile*, Newton Compton editori, Rome 1996

high heels—substitute for the sexual object, which, according to Freud, 'is not at all appropriate to constitute a sexual goal' (Sigmund Freud, *Tre saggi sulla sessualità*, Newton Compton editori, Rome 1992, p. 30), are suspended in a bubble of indefinition, inside which they can satisfy the desires housed deep within them.

Where are the heat, the reciprocal chemical responses, the mixture of humours, the usual consequences of a meeting between two bodies? What is experienced when licking the smooth surface of a shoe? The icy barrier that must be overcome to arrive at the human temperature of a foot constitutes a sexual stimulus of pure fantasy projected onto a totally cultural object as is the shoe: artificial—the work of man, of course, but still artificial—in which there is not even a distant memory of the animal body to which the tanned skin was once attached. An object totally cleansed of its meanings of biological life, dead forever, but capable of arousing vital impulses. As is underlined by Ugo Volli in his *Fascino* (Feltrinelli, Milan 1997, p. 8), 'A *double exchange* is characteristic of these figures of the fetish: what should be *only an inert thing* is presented with the most intense characteristics of life [...]; on the contrary, what is alive and concerns the *person*, as does the body, is reduced to being *purely an object*, a thing among things'. Therefore, a pure symbol, a pure artificial attraction, in a context in which 'the boundary between animate and inanimate disappears' (ibidem, p. 10). A boot that covers the leg up to the buttocks, and clinging to the thighs: a diaphragm between two beings and a distant memory of a body now knowingly punished, refused in its natural availability, become a superstructure and a barrier, the voluntary procrastination of a more banal and usual pleasure.

This type of approach to the sexual act reveals deep down an animal, eminently masculine way of feeling reality: the obstacle (the skin between oneself and the desired body); the flattery (the pleasure given and received) the fight (the enacting of an ambiguous battle); the victo-

ry (the satisfaction of the desire-wish to be dominated). Seeking domination from another is nevertheless a manifestation of will: the true perversion lies in the fact of masking it to the point of denying it, making it appear to belong to the other: you fulfil a desire—the one I have of being humiliated—that I cannot confess to feeling, a desire denied and reconstructed through your imposition. An impossible dream of neutrality, a dream of human odours transformed in a laboratory, 'the push of the organic towards the inorganic' (Volli, *Fascino*, cit., p. 40), the expression of the persistent human tendency to dominate nature. The unnatural curvature impressed upon the line of the foot by an excessively high heel recalls deforestations, or other grandiose works of man destined to bend the environment to meet his own needs. To aspire to be punished by a woman who in turn is constricted and tortured by high heels and garments which, containing forms, effect an artificial remodelling of the natural, reveals how, in its extreme manifestations, the interaction between the sexes has a circular form, consisting of flows of desire that go and return enriched by the tension towards the pleasure of the other—to the point of a freedom that surpasses the consequent sexual gender and role, not reducible to the canonical modes of sex—and how many unexplored depths are concealed by the abyss of desire and the strategies of seduction that are its daughters.

Who can say what happens in the bedroom of Cinderella and her prince after their wedding? Let us imagine that he is a pervert attracted by glass slippers and small feet: can an interpretation in a fetishistic sense be attempted of the obsessive search by the prince for the foot of the right size?

From the bedroom to the market of production: the changeable paths undertaken by desire, with its power to change custom and therefore consumption, on their way also activate the relationship between sexual subjects and designers, the most attentive of whom, through their

creations, obviously move close to the erotic imagination of potential consumers and their fluctuations of pleasure determined by custom, through the greater or lesser acceptance, by the majority, of sexual tastes considered deviant. A confirmation of this close correspondence lies in the presence on the market of magazines that also propose, as well as the fantasies of the authors transferred into images, a vast range of objects capable of satisfying the not entirely proper tastes of their readers. On this subject, and restricting the field of references for reasons of space, we would like to recall here *Bizarre*, the magazine for fetishists of every tendency founded in the United States by John Willie (John Alexander Scott) in 1946. An authentic paper forum on which were permitted the display and discussion of any type of fetishism, together with pertinent photos and drawings. *Bizarre* often proposed false advertising pages that advertised objects such as footwear with heels of unlikely heights or, for instance in issue 9, a series if disturbing muzzles destined to be worn by human beings. Its modern descendant, *Blue*, which has devoted an incalculable number of articles to feet and footwear, in turn proposes advertising of magazines dedicated entirely to feet—such as the British *Footsy*—videos and various other pretexts destined for devotees of the kind.

On the theme of the continuous crossing of confines and roles, it is fitting here to recall a photo published in an issue of the ancestor *Bizarre*, which exhibits a pair of female feet in a pair of sandals with double high heels, an illuminating metaphor of the connatural ambiguity of desire.

The times are far-off in which a magazine such as *Bizarre* could be sold exclusively by post: now highly acclaimed fashion parades are devoted to clothes and footwear which blatantly refer to fetishism, while

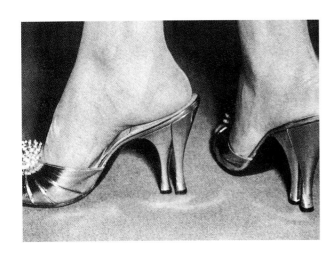

the aggressive woman, dressed in black leather or violent colours, has become a fixed styleme in the repertoire of the creatives of fashion. The boundary between active and passive seduction, between those who seduce and those who are seduced, is extremely unclear: in the case of a deeply ambivalent object such as the shoe, we can talk of a circular seductive attraction: shoes that are at the same time the objects and subjects of seduction, in the eternal entwining of desire around itself.

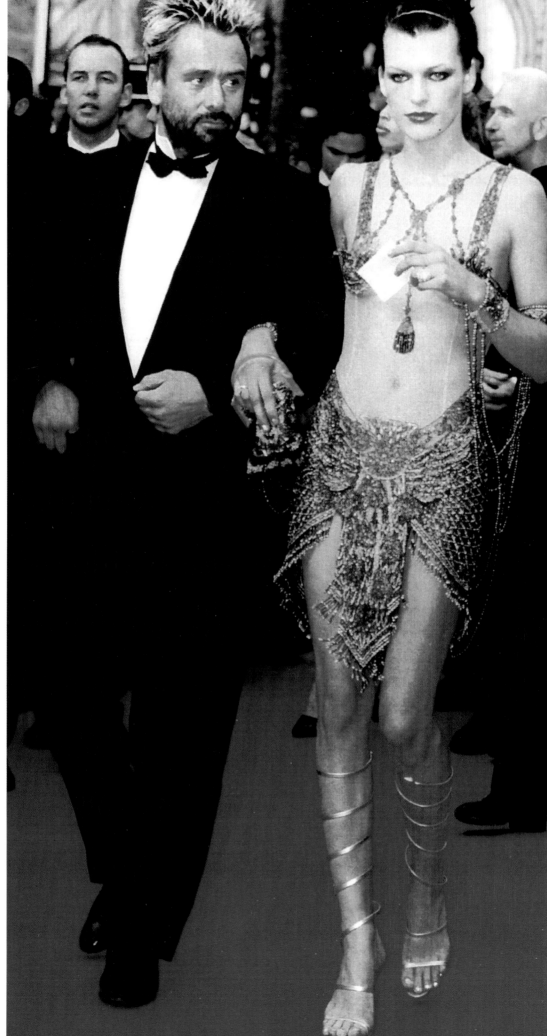

Milla Jovovich, Cannes, 1997

the Snake:

symbol

of

temptation

and of

seduction

par excellence.

But also

symbol

of medical

skill,

and

health.

Codognato

Scorpions and snakes

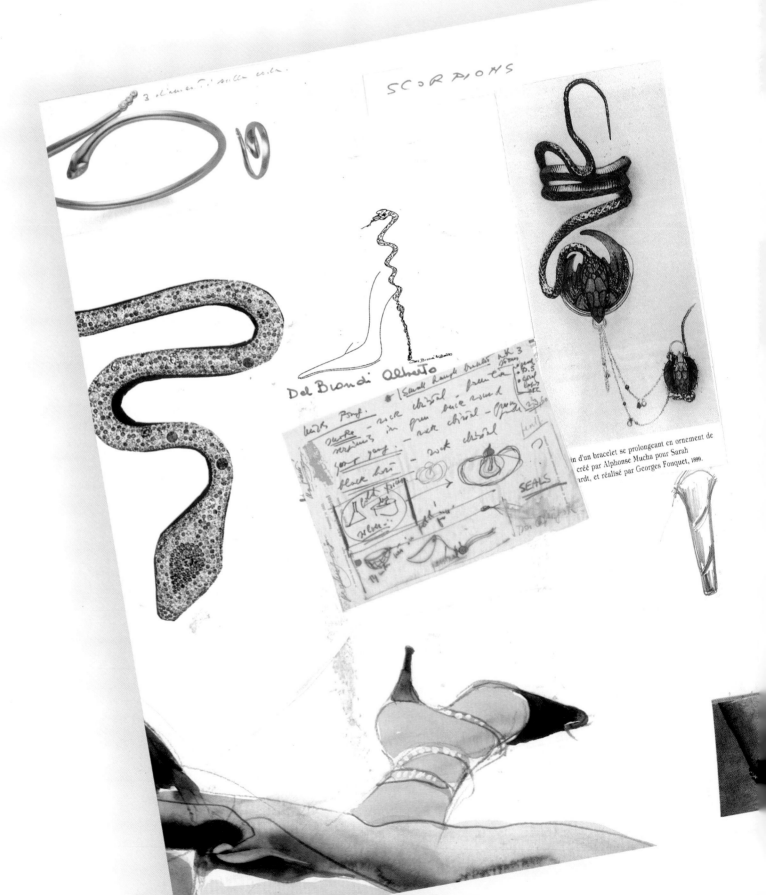

Del Biondi Alberto

SCORPIONS

SEALS

...n d'un bracelet se prolongeant en ornement de ...créé par Alphonse Mucha pour Sarah ...rdt, et réalisé par Georges Fouquet, 1899.

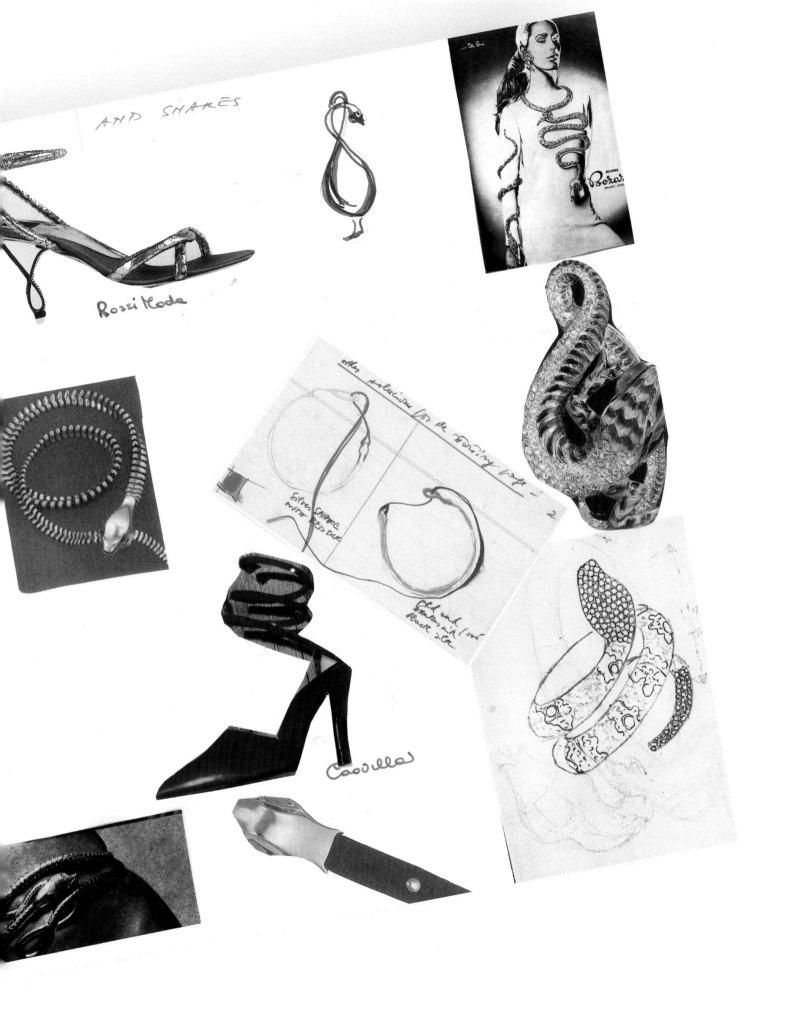

AND SNAKES

Rossi Kode

A SHOE: AN INFALLIBLE WEAPON OF TEMPTATION

Dior Collection, 1998

Antonio Lopez, *High healed sneakers*, 1976

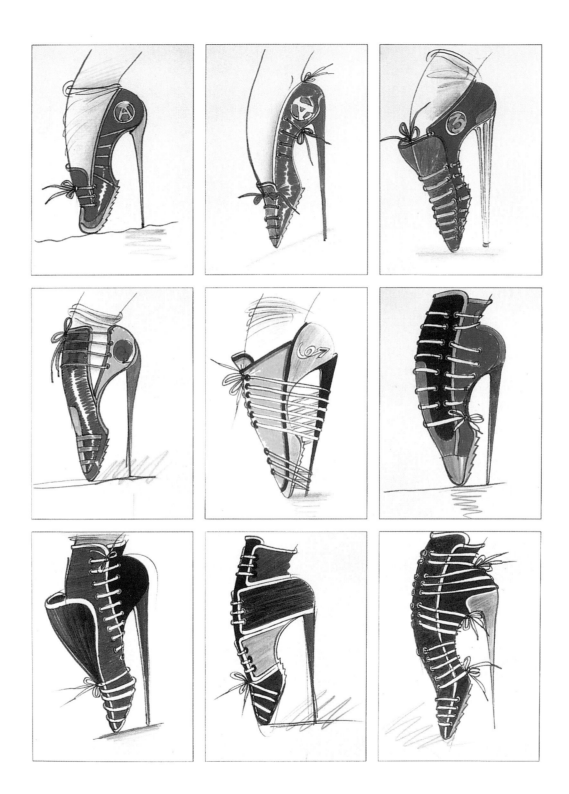

SIMOD

SPORT

NOT ONLY STILETTO HEELS TO

Elegance and seduction

have also crept silently

into the world of sports footwear.

The trainer brings out

the line of exercised legs,

of a body loved and looked after.

SEDUCE ...

There are shoes to make sure you are remembered.

And shoes to obsess.

Knowingly or not, they are chosen, bought, worn.

And if certain shoes could talk,

perhaps they would say how hard it is to stay... with your feet on the ground,

when success arrives!

looks inquisitively at a girl putting on her roller skates

in a discotheque in the USA

Since the great Italian master shoemakers brought the concept of the elegant shoe into the world, the Italian shoe has enjoyed a huge reputation, and by virtue of this fame the name of our shoemaker's craftsmanship and creativity was known long before Italian style asserted itself in the universe of fashion.

We must add to this that the artisan culture with which that particular sector of production was permeated had divided the shoemaker's product in the various regions in terms of type and quality, where over time manufacturing units had been installed, namely the Marches, Tuscany, Lombardy, Apulia, Emilia Romagna, Campania and Veneto, where the first operational plant was installed along the Coast of the Brenta in 1898 by Giovanni Luigi Voltan—a manufacturing complex that already in 1904 occupied an area of 8000 square metres with a daily production of a thousand pairs of shoes—and which had long specialized in producing shoes for special occasions.

Design Alberto Del Biondi. Photo Albert Watson

A question of skin ...

What similarity can there be we between the skins that covered Palaeolithic man twenty thousand years ago and those of a fairy-tale shoe such as *La Syrène*?

Yesterday it was used to survive, today it is created to please: the shoe is a physical and logical creation, produced by enthusiastic hands, those of the stylist, of the tanner, the shoemaker, the manufacturer.

Footwear has been manufactured over time according to aesthetic canons that on various occasions have touched on art. In this sphere, the Italians have known how to excel, taking advantage of the heritage of Renaissance and Baroque genius.

The colours of the great painters (Raphael, Ghirlandaio) can relive in an upper, the elegant line of sculptors and architects (Canova, Bernini) returns in the low neckline.

The competition of alternative materials to leather brought about chain reactions. Synthetics copied tanned leather, even reproducing its aroma. Leather has imitated fabric, fabric has replaced leather even in footwear. A recurring and temporary confusion, like summer storms.

The taste, the touch, the sense of smell and the tradition, however, in the end only seek one thing: leather. And its inventions. Let us look at prints, which have wonderfully multiplied the original prized expensive animals skins risking extinction (crocodile, reptiles), or has captured arabesques, iridescences, mosaics, landscapes, geometries.

What can we say of imitation chamois, abrasivized, painted, soft leathers, metallized, parchment papers, laminated and so on? Countless masterpieces, hundreds of specializations, thousands of creators and million of consumers.

All in love with leather.

Transforming iron into gold, common into precious. This dream has accompanied man for centuries, generating immortal legends such as that of King Midas: dreams, however, rarely come true.

Man has succeeded, however, in making lasting what, by its nature, tends to disappear, by discovering tanning way back in prehistory.

Thanks to this craft, constantly improved over the centuries, animal skins challenge time, they defend man from the elements, they rise to the dignity of artistic materials.

Archaeology has established with certainty that certain prehistoric instruments, which have resurfaced from underground, were used for working skins. Certain evidence exists of flourishing tanning activities in the most ancient civilizations, from the Sumerians to the Egyptians.

Over the course of the centuries, techniques were continually improved: from treatment with fatty substances to acacia pods, from alum to pine bark. These were the first experiments of pre-Christian peoples, in the search for new strategies to confer duration to a perishable material.

Emblem of art of tanning,
1600.
Venice, Museo Correr

Skins in fact, composed three quarters of water, tend to decay; simple curing does not solve the problem, since it makes them unusable: a special treatment is needed, one that maintains the fibrous structure unchanged.

Different solutions were then to be adopted during the process of evolution of the tanner's trade. Three main processes made headway: vegetable tanning (with tannin), fish oil (suede finish) and mineral (white tanning). From the second half of the nineteenth century, new methods were to be developed, with passage from chrome to chemical tanning and with the introduction of machinery for fast tanning, started thanks to rotating barrels.

Man intervenes with nature, accelerating procedures to an ever greater extent and obtaining products of great quality increasingly quickly.

The treatment of hides is only the first phase in the exploitation of the material. After the tanning baths it is the time of dying, padding, curing. At the end of the process, man intervenes again, eliminating the last imperfections and adding the finishing touches.

It is the final phase of human action on the material. Now the hides are ready for further exploitation: that of the major artisan workshops, from shoemakers to leather goods producers. The magic alchemy of tanning becomes the source of inspiration for man, who now adds his own essential work to the work of the tannery.

Today evidence of this centuries-old tradition are the companies dotted all over the peninsula: from Veneto to Tuscany, from Lombardy to Campania. The heirs to an activity handed down from father to son, combining the capabilities acquired in the past with new techniques, the tanners have become artisans at the service of a certain 'look'.

In Italy, the noble art of tanning brought its representatives together in the local guilds, in Venice, Lucca, Turin, Florence. Sometimes the tanners were included among the ranks of other categories, such as that of the shoemakers. In Venice, the homeland of great tanning and shoemaking traditions, two organizations of tanners existed.

In Turin tanners gathered in just one district, the current Via Lagrange. There was great attention reserved by the Savoys to workmanship with hides, to the extent that defective leather, besides leading to substantial fines for those guilty of disseminating them, were shred to prevent their use.

In Medieval France the tanning trade enjoyed a great reputation. Only the sons of tanners could practice the trade, and to become a 'master' an apprenticeship of at least five years was required. Leather was examined by a commission of experts: if it proved to be of poor quality, it was burnt, and the tanner suffered punishment. The finishing touches were not added by

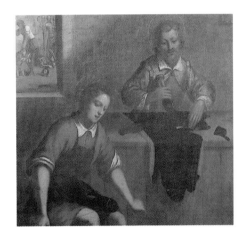

G*iulio Brunelleschi,*
The Shoemaker's Shop
of Saints Crispin and Crispinian
circa 1600,
Udine, Musei Civici e Gallerie
di Storia e Arte

the tanners, but by other craftsmen.

Spanish tanning flourished during the Middle Ages. Iberian hides enjoyed international renown: only cordovan leather produced in Spain or in Flanders could be displayed in the French markets.

In England the guilds of tanners were established in ancient times. The most well-known local products were gloves, protected by the Crown itself. In *Hamlet* by William Shakespeare, a character affirms that tanners possess great physical strength because their skin is already tanned.

ITALIAN FANTASY

The irresistible object of desire, the first contact of the woman with the land surface. Stylistic research rested over time on the meaning of colour. Red attacks: it is the image of a strong and sensual woman, capable of actively running the game of seduction; black offers mystery and secrets to be disclosed without forcing the pace.

Unusual materials and unusual combinations of colours: this is the dual concept that has made Italian workshops great. Notes of true creative distinction, which come about from the development of an architectural sign or from the study of an artistic theme linked to a given inspiration. The most important sources are the libraries: footwear came about as the fruit of historical research into human custom.

Shoes reflect man's work. They reproduce everything that surrounds the female foot, from embroidery to images, and gives it to it; they reduce every macroelement to a dimensional jewel, transmitting reality as the artistic vision.

The low line, the classic lady's shoe: high heels, foot partly bare, seems specially designed to offer women a touch of class and sensuality. The fantasy of the model maker completes the picture, with the continuous evolution of lines and ornamental nuances.

The sandal, a very ancient idea but still today the object of desire for

women: the strap contains the foot, at the same time brushing the ankle and keeping it in place with strength.

The Charleston, a sandal with a strip of leather that reaches the strap and partially covers the view of the instep.

The Chanel, that reveals the back and the front profile: simple, elegant and easy to take off...

The Richelieu, for a more aggressive, strong woman: high heels, shoelaces, foot entirely covered.

The woman's boot, in its thousand forms and variants: coloured, rigid, sometimes long, up past the knee. It accompanies the legs with delicacy and energy, bringing out their shape and femininity.

And finally the classic models for men: a derby with the crown on the tip, the moccasin with external seam, the Polish boot laced with hooks and eyelets, the riding boot made of stiff leather. Italian designers and craftsmen have reached a high level of quality in the sphere of the production of all types of footwear.

Footwear with mink, private collection

Laboratories like Renaissance shops. Placés in which the craftsman expresses all his manual skill and experience to realize creations of particular elegance, perfectly in harmony with the sensibility and wishes of the creator. Here, where the hand caresses the material offering it a perfect form, the most beautiful shoes in the world come about. Each final product is evidence of the care, ability and attention of the most sophisticated artisans in the world. To construct any shoe, it is necessary to use two forms, one for the right foot and one for the left foot. The form is very important and must be anatomically perfect; then, the stylist's imagination will be exercised on its surface.

TECHNIQUE AND SENSES: SEDUCTION DESIGNED ON THE DRAWING BOARD

The shoe is the fruit of progress, of the continued research applied to the human walk. It contains and brings together a series of small parts, synthesized in the procedure of assembly and concluded by the finishing touches of master shoemakers all over the world.

The point of departure is the form of the foot for which the shoes are destined. A problem that is not at all simple, since each foot has its own characteristics, which distinguish it and make it unique. The ideal, for the creation of each shoe, would be to have available the form or treads of the foot that is to wear it: to create the shoe, so to speak, made-to-measure. Reasons of an economic type of course require a 'standard' foot of reference, with the only difference being one of dimensions. Thus the form of the footwear comes about, made of wood or plastic, representing the embryo of future production.

The form is reproduced on a model, the reference for subsequent produc-

Original designs by Caovilla

tion, which in its realization takes the name of the upper. How is an upper made? On the front part are the tip and the toe; the back is constituted by the quarters; to complete the front and back parts accessories and filling are used; the internal part is covered by a lining; finally, we have the reinforcements, positioned in the joints. The models, such as the upper and the arch support, are reproduced in plan form before proceeding towards the graduated development of the model itself.

The model phase is the preliminary phase of the birth of a shoe. All the subsequent creations are close to the model, starting with the first phase of the production of a shoe on a model. The production process opens with the cut of the various parts composing the footwear: upper, arch support and sole, hand or machine made, according to the requirements of the cutter. In this phase the material selected (hide or fabric) is prepared according to the forms required by the model. The cut of the upper is certainly a more delicate operation compared with that of the lining cutting and arch support, since those who cut must at the same time avoid wastes of raw material and defects that could jeopardize the hold of the footwear. The machine cut is faster than hand cut and allows a more precise definition of the sections of material: hand cutting, on the other hand, is easier, has lower costs and requires less equipment.

Let us follow the birth of a leather shoe. Once the upper is cut, and with it the lining and arch support, the leather cutter puts a stamp on the leather to indicate the size to which it corresponds: a device that is small but absolutely necessary in industrial type production.

Small atlas, with infinite possibilities of combinations...

The Vamp: the evergreen ultra-high heel.

The Sexy: 'now you see me, now you don't', black, paint, gold, silver, satin.

The Sporty: no more than five centimetres of heel.

The Tranquil: ballerinas.

The Chic: the Chanel.

The Upper Class Lady: moccasins.

The Aggressive: laces at the malleolus.

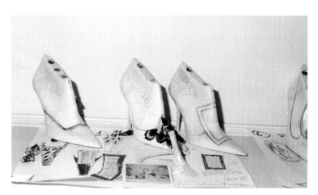

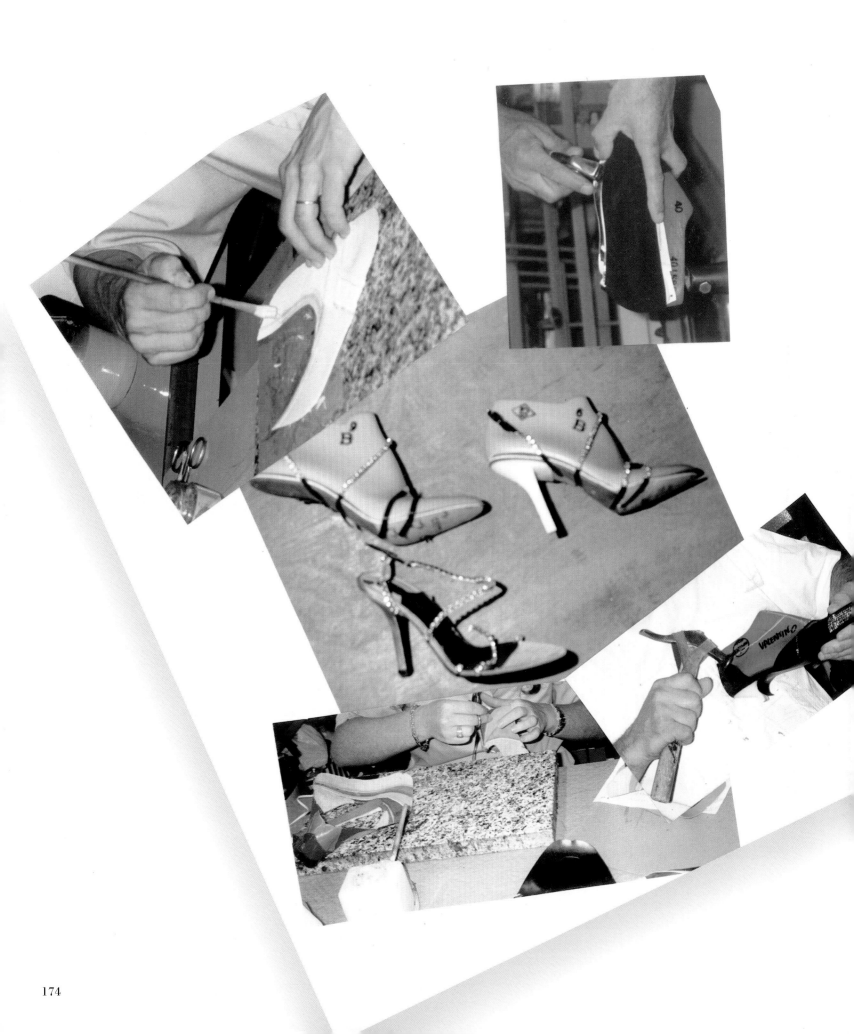

The skin, cut thus, lends itself to being worked and sewn by the skilled hands of the hemmers: but first a phase of preparation is necessary. First the check takes place on the quality of the cut and on the presence of the size stamp; then, in cases where the leather is thicker than necessary, special machinery is used to split it. The edges of the upper are perfected with the fleshing operation, which is important because it allows the special sewing of the edge and prevents the leather from hardening over time. Finally, again by machine, the edging operations and the application of reinforcements are carried out: the latter—which may be adhesive tapes, fabrics, sized cloths, special glues and others besides—serve to make the shoe last longer and confer a rounder appearance on the reinforced parts. When this phase is also concluded, the upper is ready for the hemming.

The term hemming indicates the phase of sewing the various pieces composing the upper, which may take place with the use of only machines for sewing or through gluing prior to this: the second method is used, however, by less expert hemmers. Through various types of sewing (simple joining, overlap, zigzag, moccasin), the hemmers substantially prepare the definitive form of the upper, which thus no longer appears as a split up group of parts, but as an 'almost' definitive form. There only remains the assembly with the other parts, particularly with what is under the surface (lining, heel and sole). The hemming is the phase requiring the greatest quantity of work in the production of a shoe: it is therefore the most delicate phase, because it adds quality to and enhances the final product, thanks to the actions of the expert hands. Many companies still have recourse today to the workers at home, heirs to a family tradition that has known how to adapt to industrial civilization: the workers hem and prepare the dream shoes in their own homes.

Maniacal precision. Studio Artistico René Caovilla

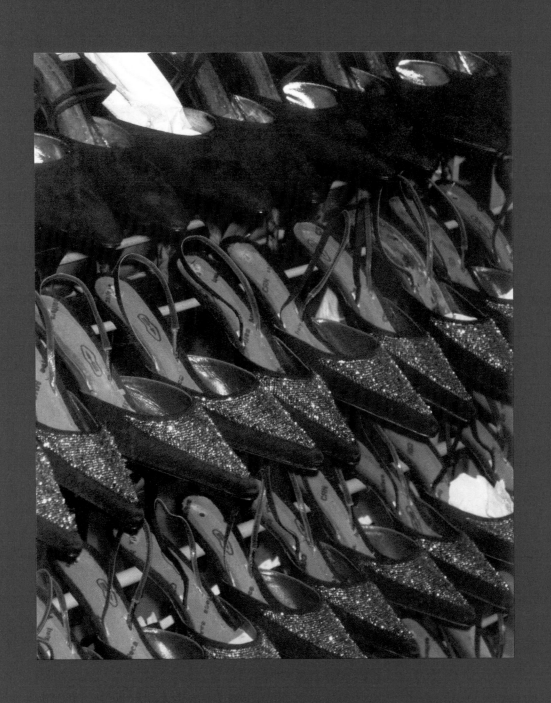

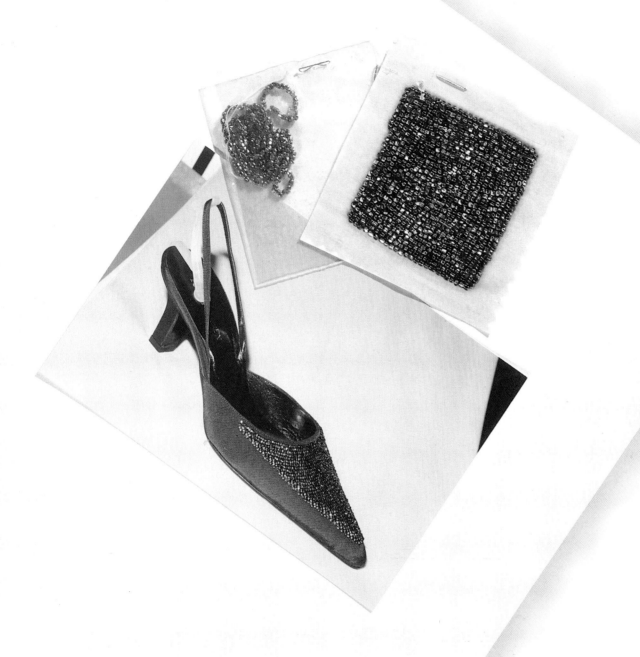

ea applied

At this point the shoe, in its individuals parts, is ready. We have the top part, the upper, already hemmed and completed; the shoe factory, in turn, will have manufactured or obtained the lining and the whole arch support (in particular the heels and sole). Before the assembly of the components, a preparation phase takes place including a few essential operations. The preparation of the sole and the heel essentially depends on the type of components produced and the system of workmanship adopted; today this phase has practically disappeared, since materials are used that have already been processed by third parties, or else the whole sole-heel unit is already connected up (the so-called 'pre-defined bottom'). For high quality footwear, soles and heels are exclusively made of leather, or, in some cases, plastic materials covered in leather. For models of lesser quality, on the other hand, there is a tendency to only use rubber or plastic. The preparation finally involves accessories, the few that have not already been inserted in the upper in the hemming phase. Everything is now ready: the model is taking on its real form, through The assembly.

The final phase requires the best technological contribution of all the production process. Also in the assembly, however, it is man that governs the machine, as always happens in shoemaking, a sector in which human work represents the key component. The variation in the construction phase depends on the type of production that it is intended to take place, based on three main categories: sandal, moccasin or closed shoe. The final construction, however, is not an operation of short duration: it in fact requires a long series of diversified operations that are performed by special micro-departments in the shoe factory. In this way a means of transport, the hand-rail, is necessary to distribute the work phases among the individual 'specialists'. There are sixteen 'typical' phases of assembly: they range from the fixing of heels and soles to the application of the toes, from the fixing of the linings to the blowing (a phase wich is carried out under heat to remove any possible imperfections).

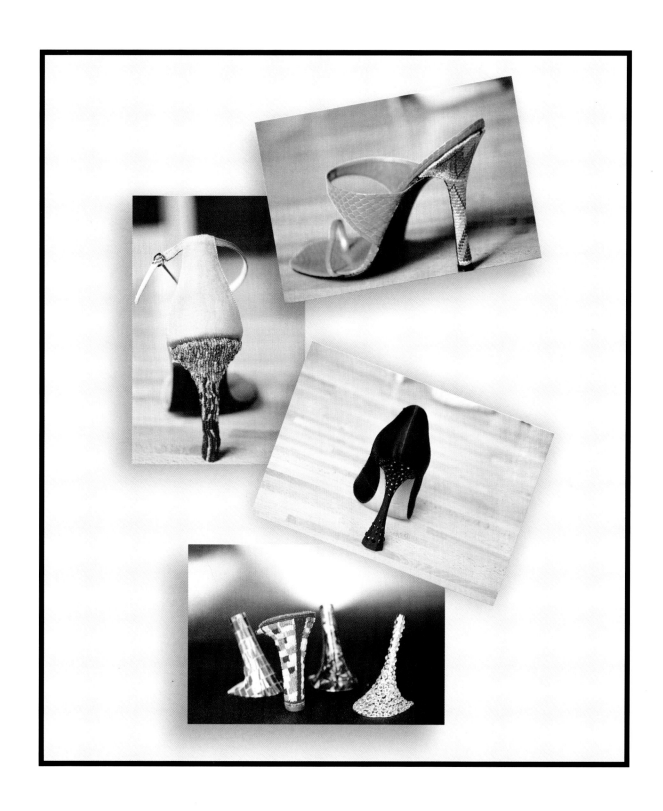

Now the shoe is indeed ready. But for the master shoemakers it is not enough: they have imposed a further phase, to confirm the quality of the product and to make it even more unique. This phase takes the name of finishing. It starts with the colouring of the heels; this is followed by the ironing of the upper, the colouring of the sole, the branding and so on, until the final quality check. At this point only the boxing is left. And the shoes, objects of art and of seduction, truly see the light of day.

Creation from a haute couture inspiration

Audacious and prestigious style, the synthesis of aesthetic elements from Classicism

with a modern conception of design, in each individual creation: this is Italian

style, the object of worship throughout the world, both traditionally and today.

Countless shades and degrees of colour that when added to a shoe become snapshots

of a season, a place, the souvenir of the time and space.

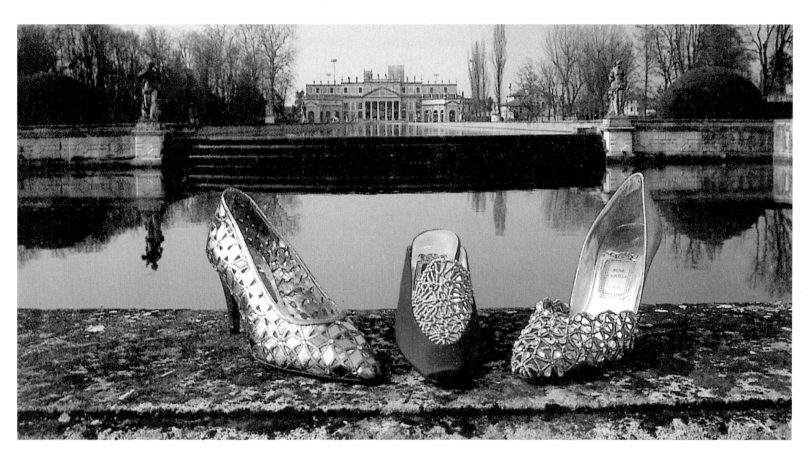

Shoes on the Banks of the Brenta, Villa Reale of Stra

the souvenir of the time and the space

What remains to us

of the work of nameless craftsmen

illuminates for a moment

pages of everyday life and history,

allows the taste to be gleaned

of people far away in time and space,

who have cherished our own desires and needs:

moving, walking, discovering the world

and winning the love of the beloved.

Pleasing. And being pleased.

Thinking of the future...

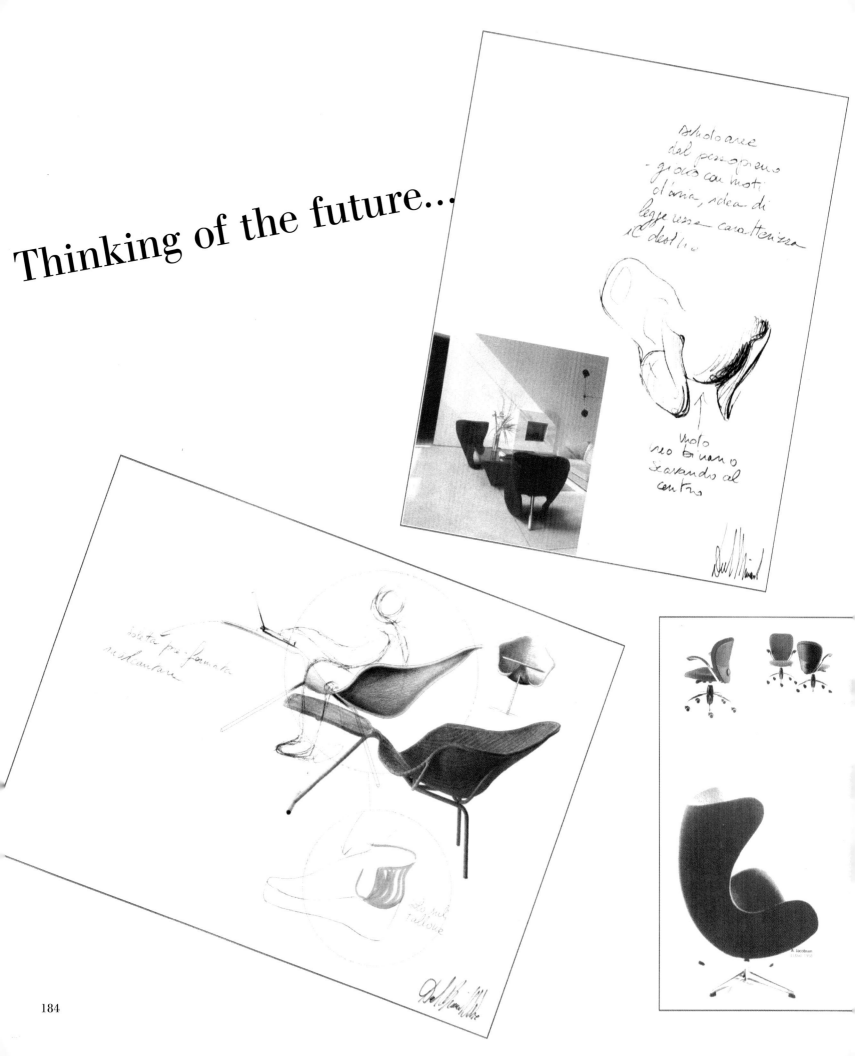

...walking towards the Third Millennium

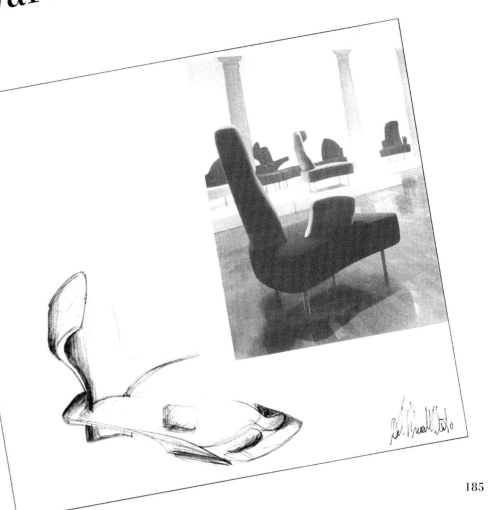

185

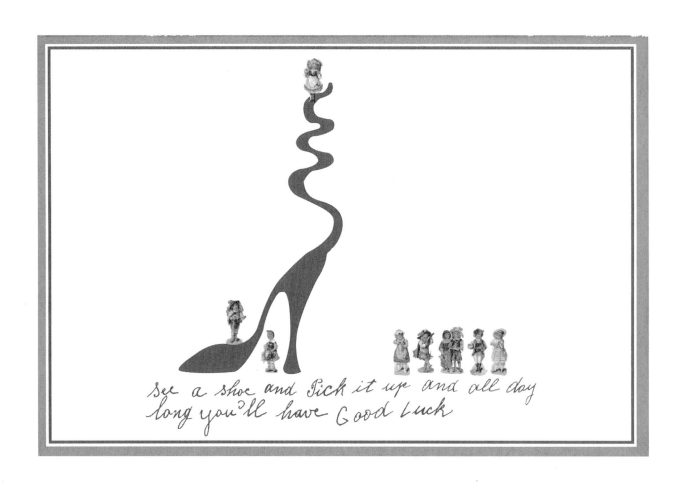

See a shoe and Pick it up and all day long you'll have Good Luck

The voice, the gestures, the gaze:

the body has learnt to talk,

and does not know how to stop...

Even when it dresses.

Because it is dressed with messages,

AN IRRESISTIBLE WOMAN:

often unknowing ones.

But this does not happen by chance.

EVERY WOMAN CAN BECOME ONE

Choices are made with reason

or with the heart.

IF SHE BELIEVES IN HERSELF

And shoes, the final touch,

the spies of our mood

and our character,

throw messages that many,

today, have learnt to read

and interpret... take care!

Di paolaburani..Caovilla
(Lucerne 1997 - Fate 1998)

- SKIRA
- Ludovico Eleuteri
- Paolo Singaglia
- Biby brava!

Ho iniziato Subito a Studiare

LIBRERIA

È un sogno...!

LA CALZATURA OGGETTO D'ARTE E DI SEDUZIONE ECC.

ESAURITO

THE HISTORY

Documentarsi Sempre!

può esser lacuoso alla fine Rend ci si accorte...

Giorgia
mi ha sempre incoraggiato!?!?!

Dalla base deve parti. fui bella!!!

le Se
Ti a
Ser
sole
mou
jui
so
part
at
lauc
dei
Menaggi...

il TEATRO

SIENA

Fattoria Kugnano

Una FISSA
Una Mania!
"La Salvezza
dell 'Uomo"!
Mi diverte...

Siena: Estate Caldissima, ma
sensazione al ...

Fernando

È propri-
bravo! ♥
anzi
bravissimo!

EDO

I miei
Uomini
(settori!)

Come si famo le Scarpe?

Ci Vuole Tanta Fortuna
e dicono che le Scarpe
ne fortuno...

Carlo e Pia Sostenitori
grandi Sostenitori

a Parigi
a Londra
e N.Y
sfilate
sfilate

Manolo
un genio!

Ho scoperto
un Modello!
Non ne faccio
tanti!
Ma ce ne sono
tantissimi
forse i più
ecco perché
tutti: Hanno conosciuto
per le Belle
Scarpe!

189